IMAGES
of America

# MILWAUKEE
## WISCONSIN

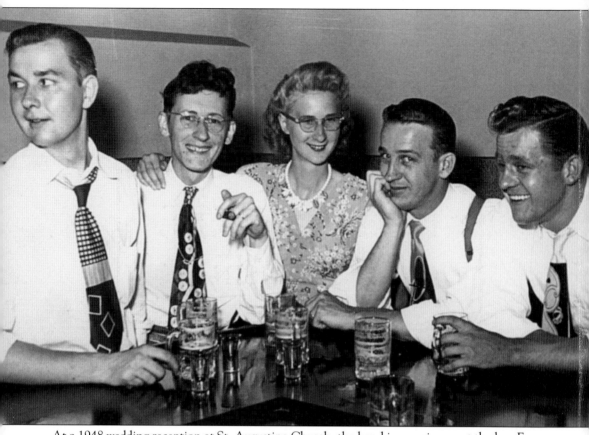

At a 1948 wedding reception at St. Augustine Church, the band is warming up at the bar. From left to right are the following: Roy Zajac; Ed "Smokey" Mencfeldowski; Rita "Bubbles" Mencfeldowski (Roy's sister); Chet Zurawik, who later played banjo with Louie Bashell; and Eddie Barborich, who had a polka band called the T-Bones. Ed, Chet, and Eddie made up the band for the reception. Love the ties, guys!

*On the Cover:* Marshall Cain loved motorcycles. His Harley-Davidson is pictured on page 77, as is his Excelsior Auto-cycle. Don't skip the rest of Marshall's photos; his story begins on page 75.

IMAGES
*of America*

# MILWAUKEE

## WISCONSIN

Richard Klatte Prestor

ARCADIA

First Printed 2000.
Reprinted 2002, 2003, 2004.

Published by Arcadia Publishing,
Charleston SC, Chicago IL, Portsmouth NH, San Francisco CA

Printed in Great Britain.

Library of Congress Catalog Card Number: 2002103215.

For all general information contact Arcadia Publishing at:
Telephone 843-853-2070
Fax 843-853-0044
E-Mail sales@arcadiapublishing.com

For customer service and orders:
Toll-Free 1-888-313-2665

Visit us on the internet at http://www.arcadiapublishing.com

# DEDICATION

*I dedicate this book to three very important groups of people:*

*The photographers*
*those competent, behind-the-lens professionals and amateurs whose joining of art and*
*mechanical processes created the images presented here*

*The families*
*and others thoughtful enough to simply save and hold old images*
*rather than discard them as so many others have done*

*The libraries, librarians, and amateur historians*
*who preserve and organize so much of the information necessary for history's survival.*

# CONTENTS

# ACKNOWLEDGMENTS

I offer a sincere "Thank you" to all the supportive and helpful folks who made it possible to research and assemble the material necessary for this book. Large thank yous go out to the following:

David H. Thielke—retired photographer and operator of the James Murdoch photography studio. Mr. Thielke worked with James Murdoch for many years and has kindly permitted my use of many of Murdoch's city-scene photographs.

The *Roman B.J. Kwasniewski Collection* of the Golda Meir Library Archives, at the University of Wisconsin-Milwaukee, and to Tim Ericson and Kathy Koch for their assistance in my research with that collection.

The staff of the Milwaukee Central Library, and particularly for the help received in the Frank P. Zeidler Humanities Room.

Steve Daily of the Milwaukee County Historical Society.

Two important literary references: *Wright's Milwaukee City Directory, 1863–1960*; and *We, the Milwaukee Poles*, by Thaddeus Borun, 1946.

Thank you, also, to these folks who responded with help in various forms:

Sister Suzanne Rene, School Sisters of Notre Dame
Sister Mary Gregory Smith, Mount Mary College
Clayborn Benson III, Wisconsin Black Historical Society/Museum
Tim Cary, Archdiocese of Milwaukee
Karin Newman, Milwaukee County Zoo
Sergeant Steve Basting, Milwaukee Police Department
John Bartel, Wisconsin Electric Power
Gordon Simons
Len Borkowski
Eric Levin
Bill Klatte

Miles Etzel
Jim Makarewicz
Irene B. Goggans
Arnoldo Sevilla
Ellen Kozak
Jayne Williams Klatte
George A. Hardie Jr.
Marlene Bergman
Norris Knight
Owen Klatte
Kathryn Klatte

And last but not least, my editor at Arcadia Publishing, Mr. Patrick M. Catel.

# INTRODUCTION

In April 1834, the *Green-Bay Intelligencer* newspaper reported that a sawmill was being erected in a new settlement on the Milwaukee River. Less than one year later they printed, "Milwaukey [*sic*], which 10 months ago, had only a single trading house, has now some 20 or 30 houses, and two or three saw mills."

Yankee settlers and land speculators had moved in and were here to stay. Milwaukee was a part of the Michigan Territory then, and to most Americans of the time, we were the distant Northwest territory. New settlers generally found Wisconsin to be a peaceful wilderness, and our settlement flourished.

The steady growth was never wholly due to the influx of ambitious Easterners, though. In ever expanding numbers, Europeans also made their way here, not merely as settlers, but frequently as hard-working business owners, skilled laborers, and artists. They were determined to make Milwaukee their home, and in this new homeland they surrounded themselves with, and influenced the entire community with, their old traditions and languages. Thirty years after our first newspaper write-up, Milwaukee was a well established city, brimming with potential.

I begin this book near the end of the Civil War, simply because that is where my photograph collection begins. This is not a "history of Milwaukee" per se, but rather a lighthearted look at the people who *made* Milwaukee's history. On many personal levels, you will see how people lived, how they worked, and how they entertained themselves. This picture book is intended to keep history alive and on the streets. Relax and enjoy.

# PREFACE

If one picture is worth a thousand words, then three pictures should tell a short story. While many people enjoy single-picture glimpses of our past, the history of any moment becomes clearer when viewed from several perspectives. Wherever possible in this book, I use multiple pictures so that you may more clearly *see* how people lived. Several pictures of a place, or of one person's life, naturally tend to expand the reader's understanding.

As you read this book, you may be able to do more than just enjoy these pictures. In researching these little windows to the past, I have been unable to completely identify some people, places, and objects. If you can provide solid information or photocopies of reliable documents that further identify any photographs here, you will be helping me preserve the accuracy of our history. I will certainly appreciate any identification help you can provide. You will find my mailing address on the copyright page (page 4).

*In reading this book, please keep these points in mind:*

1. Quotations found in captions with no credited source signify direct quotes of information found on the original photograph.

2. "c." stands for "circa," which means "about."

3. The photographer of every picture is credited after the caption, when I know his or her name.

4. In 1931, Milwaukee re-arranged its street numbering system. Many streets' names were also changed. In the Appendix (page 123), I list all of the street names that did change. For more information about numbering changes, visit your Milwaukee public library or the Milwaukee County Historical Society.

5. All pictures are from my personal photograph collection except those marked, "courtesy of . . ." My thanks, again, to those who allowed me to borrow their photographs for this book.

# One
# EARNING OUR DAILY
# BREAD

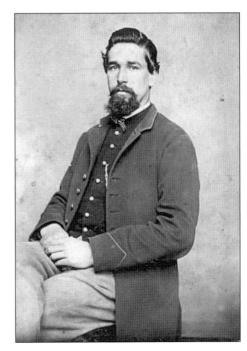

The information on this photograph stated, "W.H. Harlow Co. I, 30th Regt. Wis. Vol." The military draft occurred in Milwaukee in the late fall of 1862, and several companies of troops were stationed throughout the city to control anti-draft rioting. Civil War volunteer William Harlow served in Milwaukee from September 12, 1863, to September 30, 1864. Company I was then assigned to Dakota Territory before going to Kentucky. During the war, the 30th Regiment had one man die in action, one die of wounds, and 67 die of disease. Harlow was discharged August 1, 1865, on disability. (Circa 1864 photograph by Alexander Marquis Jr.)

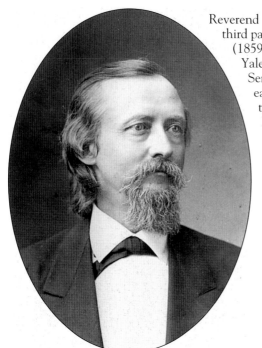

Reverend Charles D. Helmer (1827–1880) was the third pastor of Plymouth Congregational Church (1859–1865). Born in New York and a graduate of Yale and the New York Union Theological Seminary, he chose Milwaukee over several eastern cities for his first pastorship. He was a trustee of Beloit College and married Milwaukeean Susan Bonnell. He later pastored in Chicago and Brooklyn, but at his death was buried here. (Photograph c. 1868 by H. Rocher.)

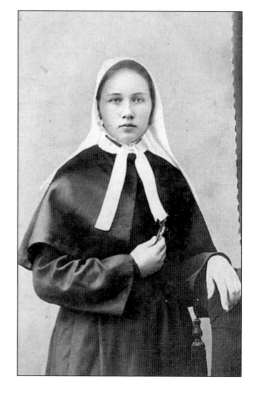

This young postulant (or "candidate") was given that designation because she had not yet taken her solemn (final) vows. Holding a crucifix near her heart, she was a member of the School Sisters of Notre Dame (SSND) when this picture was taken around 1881. This particular style of dress was worn by all SSND candidates until the early 1970s. The bonnets, allegedly heavily starched and hard on the ears, were done away with in 1959. (Photograph by Frederick W. Streit.)

These unidentified Sisters belonged to the School Sisters of St. Francis order, founded in 1874 in New Cassel, Wisconsin, by three adventurous German women. Dedicated to the "care of needy people everywhere," the order grew to provide orphanages, schools, hospitals, and religious guidance in 18 countries. They built their new Motherhouse in Milwaukee in 1887, Sacred Heart Sanitarium (1893), and later, Alverno College. These c. 1900 Sisters' habits include a characteristically Franciscan symbol—the rope-like "cincture." The knots represent the five wounds of Jesus. (Photograph by Charles F. Voight.)

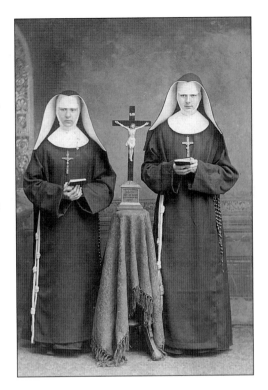

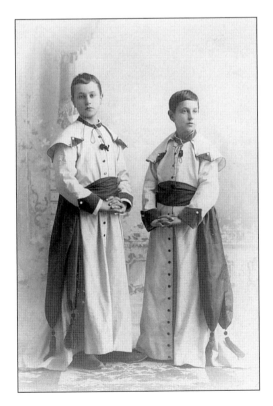

Altar boys do not properly belong in this chapter because they are not "working," but this fine image fits in well with the previous photographs. The boys are unidentified and, in fact, so are their garments. With large, fancy, tasseled sashes, floor-length cassocks, and special capes, they are ornately prepared for some special service; perhaps an ordination, or Christmas or Easter. (c. 1898 photograph by Charles Brodesser.)

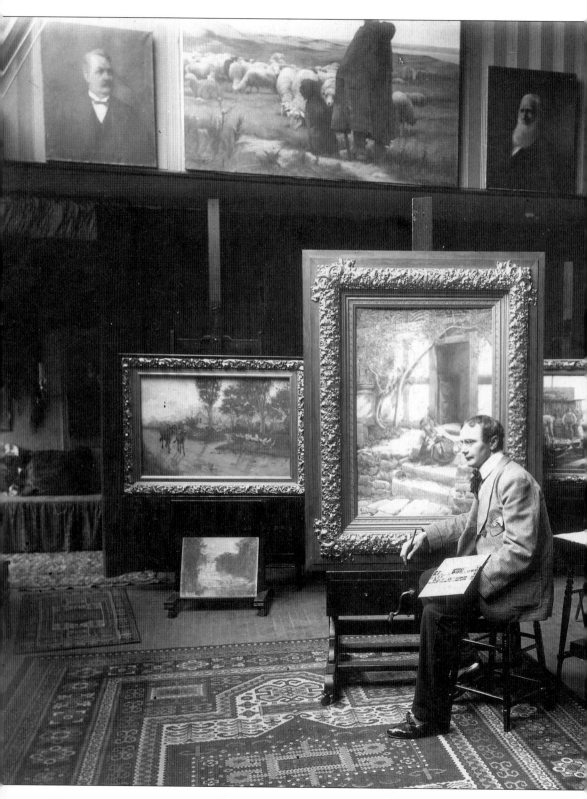

Frank Enders (1860–1920) was the son of a downtown saloon keeper. As a teenager, Frank was a student of landscape artist Henry Vianden before attending art school in Munich. Enders opened his own Milwaukee studio in 1885 and immediately accepted work painting portions of the Battle of Lookout Mountain on one of Milwaukee's Civil War panoramas. Posing here in Oscar Wilde–like finery, Enders was a serious artist who became a founding member of the Milwaukee Art Association (1888) and was allowed to photograph paintings in the Layton Art Gallery. He remained, however, a struggling artist who often lived with his father. In the late 1890s he joined the faculty of the Art Students League, becoming noted for his fine copper etchings. His painting *Jones Island Fisherman*, partially visible behind him here, has been hanging in Milwaukee's Central Library for many years. (Photograph c. early 1890s.)

This unidentified Milwaukee fireman worked in a fire department that had all horse-drawn equipment. Their steamers and hose wagons all had steel tires that made rapid travel over cobblestone streets noisy and uncomfortable. According to *Beertown Blazes*, by R.L. Nailen and James S. Haight, the average work week for a fireman in the 1890s was about 140 hours, and the basic pay rate was roughly $70 per month. (Photograph *c.* 1895 by Nathan L. Stein.)

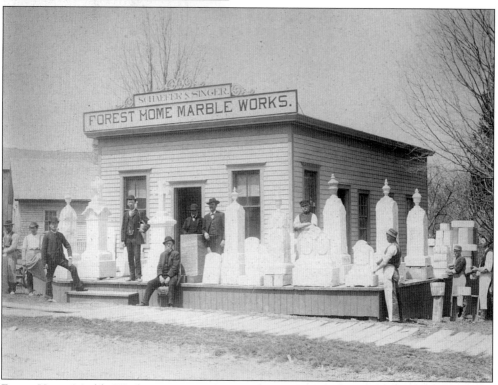

Forest Home Marble Works was across the street from Forest Home Cemetery, which began with 72 acres in 1850. By the turn of the century, nearly 200 acres were available for cemetery plots. Naturally, marble and monument makers found business there. A. Schaefer & Co. was in business by 1887, and Anton Singer briefly had his business on Eleventh and Washington in 1890. Apparently they combined. Schaefer & Co. provided carved marble until the early 1930s. (Photograph *c.* 1890s.)

14

This unidentified young police patrolman is smartly dressed for his photograph, wearing the ceremonial braided baton. The uniform coat and hat were pretty much the standard since 1888, when the new police chief, John Janssen, had decreed that all patrolmen should wear the same style uniform. Note that this policeman wears the new, modern, 1904-design badge on his coat, while still wearing the old-design shield on his hat. (Photograph *c.* 1904.)

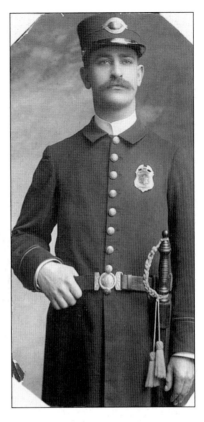

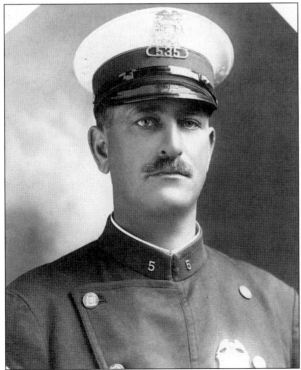

Here we have the same patrolman 15 or 20 years later. Most striking is his change from the very old-fashioned-looking uniform to a lighter looking, more fashionable one. The designs of his badge and shield (on hat) are complementary now, but the patrolman has been transferred from the First District to the Fifth. (Photograph *c.* 1930.)

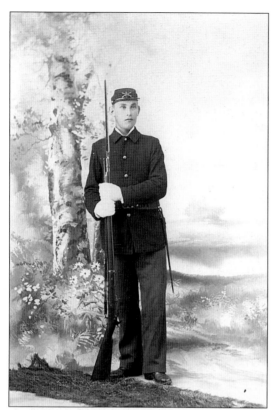

As many other patriotic or adventure-seeking young men did, this Milwaukee soldier may have enlisted to fight in the Spanish-American War. Cuba was revolting against Spain, when on February 15, 1898, the battleship *USS Maine* exploded and sank in Havana harbor, taking two-thirds of her crew with her. This incident officially sparked our war with Spain. "Remember the *Maine!*" (Photograph *c.* 1898 by Eldridge K. Baker.)

This rather Spartan office is part of the insurance firm of Chris Schroeder & Son, Inc., at 210 East Michigan Street. Schroeder began by selling fire insurance policies out of his third-ward butcher shop in 1888. He soon added neighborhood mortgage banking, and his reputation brought in plenty of business. His son Walter became company president in 1912, rapidly expanded the business, and built the chain of Schroeder Hotels. The insurance business thrives to this day. (Photograph *c.* 1906 by Joseph Brown.)

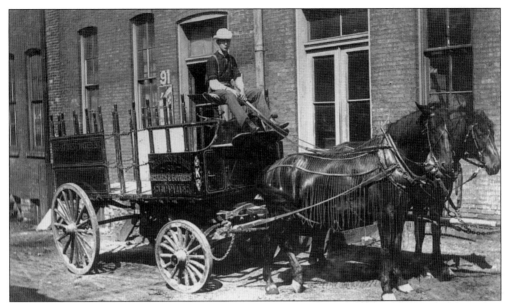

This almost classy-looking delivery wagon, with fly-aproned team of horses, is painted, "Chas. Koss & Bros. Co., Brewers' & Bottlers' Supplies 85–87 West Water St." (The 1931 street name changes renamed this street Plankinton Avenue.) In 1915, the business moved to the east side of the river. Charles Koss sold brewers' and bottlers' supplies until 1928 (through most of Prohibition). After that, Wright's Directories listed him under Bottlers' Supplies & Machinery until at least 1960. (Photograph Summer, 1903.)

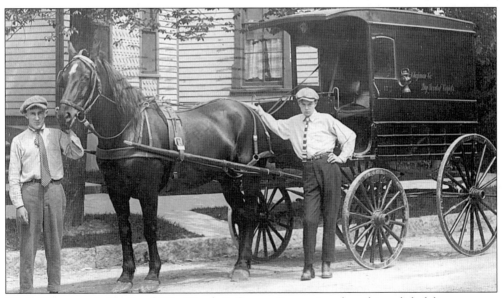

"T.A. Chapman & Co.," and "Dry Goods & Carpets," are painted on this stylish delivery wagon from Mr. Timothy Appleton Chapman's bustling enterprise (wagon is numbered "17"). The department store, begun in 1857 on West Water Street, carried quality clothing and fashionable household goods. The firm moved to (East) Wisconsin Avenue, grew steadily, was destroyed by fire in 1884, and was rebuilt seven years before Mr. Chapman died. The 411 East building now occupies the site. (Photograph c. 1915.)

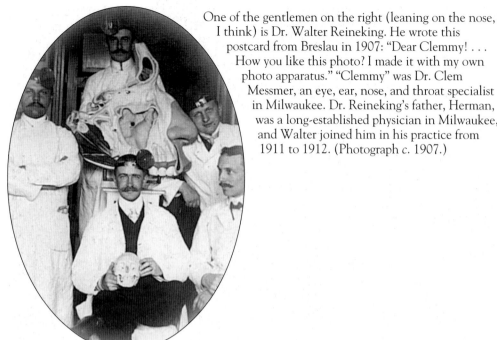

One of the gentlemen on the right (leaning on the nose, I think) is Dr. Walter Reineking. He wrote this postcard from Breslau in 1907: "Dear Clemmy! . . . How you like this photo? I made it with my own photo apparatus." "Clemmy" was Dr. Clem Messmer, an eye, ear, nose, and throat specialist in Milwaukee. Dr. Reineking's father, Herman, was a long-established physician in Milwaukee, and Walter joined him in his practice from 1911 to 1912. (Photograph *c.* 1907.)

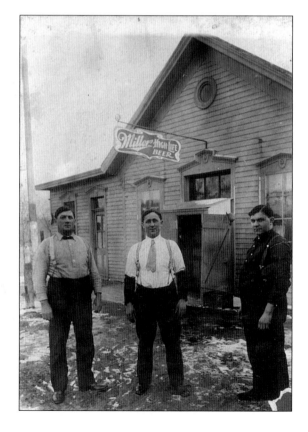

These sturdy, imposing gents posed around 1909 near what is now South Twenty-first Avenue and Maple Street. The name "Miller High Life," first used in 1903, was the winning entry in a contest that Miller Brewing Co. sponsored to name their premium beer. The slogan, "The Champagne of Bottled Beer," was adopted in 1906. Miller Brewing grew steadily, Prohibition notwithstanding, but World War II's ingredient shortages reduced Miller to only one brand by war's end: Miller High Life.

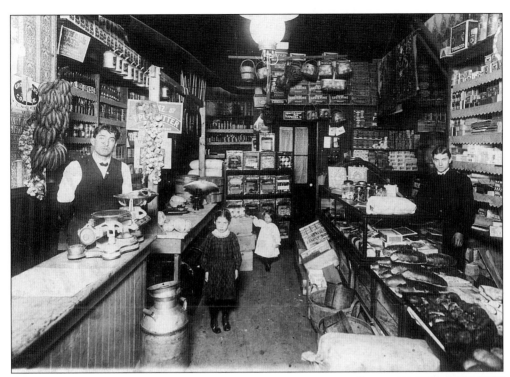

Frank Tarkowski emigrated from the German empire's Kreis district in 1887 at the age of six. In 1907, he opened this Milwaukee general store, located at 1204 Fourth Avenue, where he sold canned goods, candies, throw rugs, tobacco, candles, fruits, bakery, peanut butter, baskets, etc. Frank is pictured at left, with his daughters (from left to right) Blanche and Helen, and then their clerk. I do not know how long the shop was in existence, but Frank died in 1915. (Photograph 1908, courtesy of Mr. and Mrs. Thomas Tarkowski.)

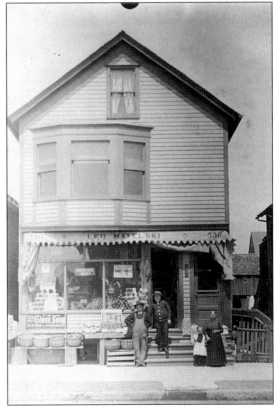

Leon "Leo" Matelski poses in his coveralls with his family in this view of his grocery store at 550 Maple Street. On display outside is a wide variety of fresh fruits and vegetables, including a large stalk of bananas behind Leo, as well as many packages of seeds. Signs advertise Ivory soap, "Gloss Soap For The Laundry," and "Fresh Milk Daily." The city directory listed Leo as a cook in 1903, but he was listed as a grocer from 1904 to 1916. (Photograph 1909.)

Owen J. Williams (1883–1967), a Welsh, 1903 immigrant with only a third-grade education, met Jane Persis Humphrey at Milwaukee's Welsh Church. Throughout their courtship, Jane spoke only English, forcing Owen to learn the language. Before they married she revealed that Welsh was also *her* first language, but she had known he would need English to succeed. His new 1912 firm, Williams Bros. Carpenters, grew for five decades, with clients such as Northwestern Mutual Life and the first 25 years of the Sentinel Sports & Boat Show. (Photograph *c.* 1914 by Jane Persis Williams.)

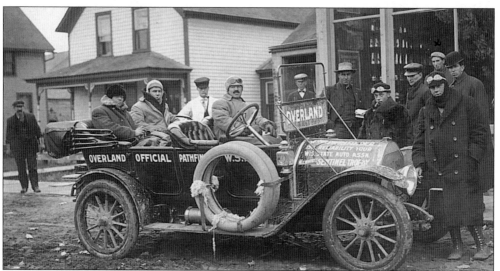

This is the "Overland Official Pathfinder [of the] Wisconsin State Auto Association." The *Milwaukee Sentinel* put up a trophy for this "1911 Reliability Tour." The driver stands in front ready to crank the starter, and the front passenger has a pencil and note paper poised for writing. Maybe they were just practicing, but this real-photo postcard was mailed and postmarked on November 21, 1909. (Photograph 1909.)

Patriotism before 1920, even well before World War I, was widespread in America. Folks proudly displayed the flag at all sorts of places and times. Photography studios were pleased to participate in recording patriotic moments, and they didn't hold back when a soldier walked in. Milwaukeean Frank Rakowski mailed this picture of himself to his Midland Avenue friend, Mike Kluczynski, from "35th Co., 9 Battalion, 160 Depot Brigade, Camp Custer, Mich." (Photograph *c.* 1917.)

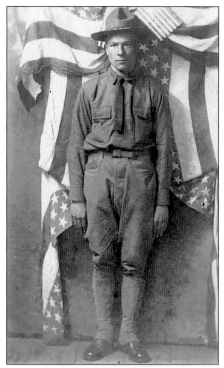

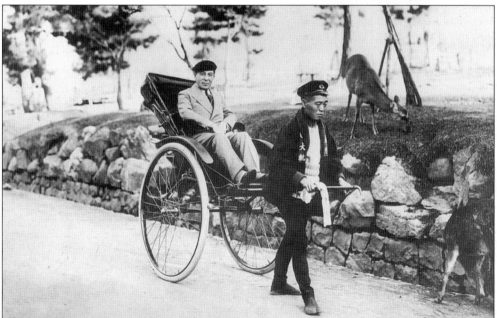

George W. Patek enjoyed a rickshaw ride while on vacation. He and his brother Mark were first listed in business in 1896 under "Rohde and Patek Bros.," dealers in glass-plate and windows. In 1898, Patek Bros. began operating on their own as manufacturers and jobbers of paints, oils, and glass. The firm prospered along with Milwaukee and was located in the same downtown, Water Street area until well after 1933, when George was no longer listed in the city directory. (Photograph *c.* 1920s.)

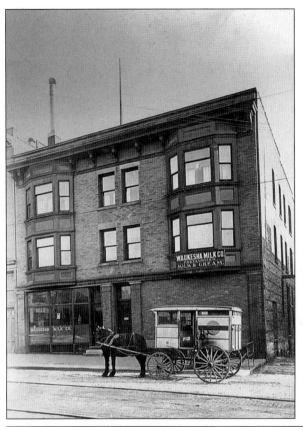

In 1888, Waukesha natives (but Milwaukee residents) and brothers, George and Michael Seybold, purchased a Milwaukee dairy and named it the Waukesha Milk Company. The firm was located at 346 Sixth Street. They worked hard and built up the business, selling both wholesale and retail. By 1892, the company employed ten men and six teams of horses to make deliveries. (Photograph *c.* 1920.)

A brief Waukesha Milk Co. description in "Milwaukee Of To-Day" (*c.* 1892) says the Seybold brothers have a "perfect knowledge of the best sources of supply, and the success they have achieved is the logical result of their ability and industry." Obviously the business continued to prosper, as they later added a motorized vehicle to help reduce the work load of the resident looking out the second-floor window. (Photograph *c.* 1920.)

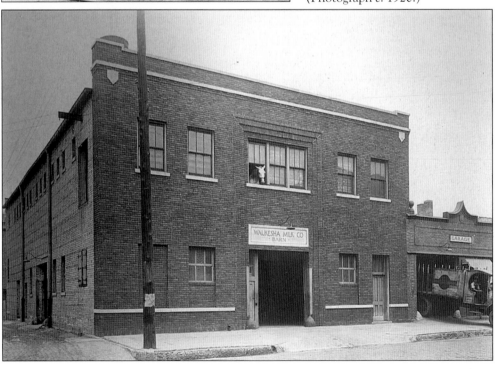

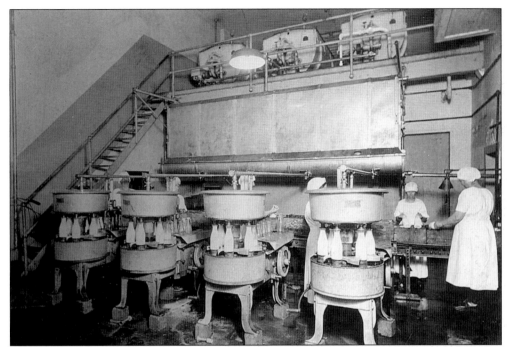

Waukesha Milk Co. also sold dairy products and eggs throughout the Milwaukee area. They made their own butter and cheese, and by 1892, "Their milk and cream, of which they handle from eight hundred to one thousand gallons daily, have the indorsement [sic] of many eminant [sic] physicians in this city, who have used and recommended them for their absolute purity and rich and nourishing qualities." (From "Milwaukee Of To-Day.") (Photograph c. 1920.)

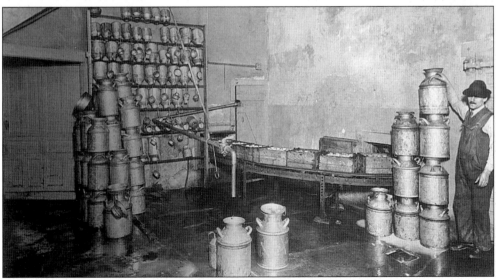

Milk arrived from the farms in milk cans and was pasteurized and processed in the large, second-floor tanks visible in the photograph at top. Gravity-fed pipes then filled a small holding tank over each bottling machine. The ladies in clean white garments placed finished bottles into wooden crates, which were pushed over roller tracks and through the milk can room, all ready for door-to-door delivery. (Photograph c. 1920.)

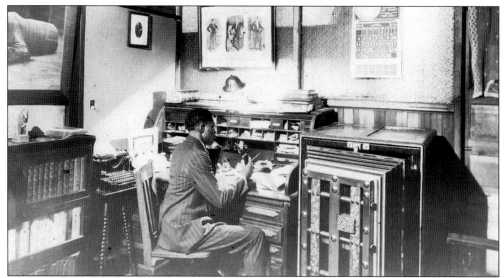

Clarence L. Johnson and his wife, Cleopatra, both 1919 graduates of Tuskegee Institute, moved to Beloit but found no steady work. "C.L." investigated Milwaukee, and on October 8, 1920, he opened Ideal Tailors. While the Johnsons were well trained in tailoring, finding rental space was tough. A friendly white salesman rented a store for six months under his own name, but let Johnson set up his own shop. The building's owner later raised a ruckus, but Ideal Tailors was in business. (Photograph April 1926, courtesy of Irene B. Goggans.)

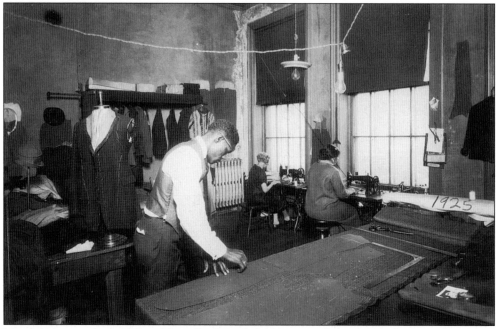

Mrs. Johnson worked at Johns-Manville Co., while C.L. struggled to build a business downtown near Michigan and Plankinton. Sound business practices earned him local respect and increasing business. Johnson, working here, had 12 employees after six months, both black and white. When possible, Johnson worked to help others in the community, offering jobs, housing for students, and hope. (Photograph c. 1925 courtesy of Irene B. Goggans.)

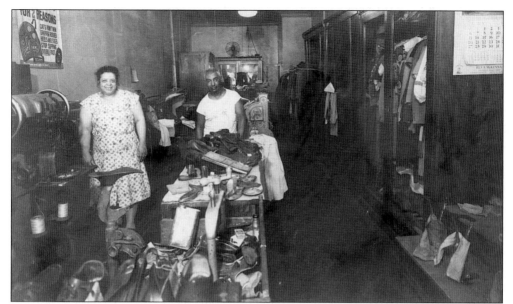

Mrs. Johnson proudly smiled for this picture in the shop's front room when she was working full time at Ideal. Hat blocking and shoe repair had been added to their tailoring business. Ideal Tailors successfully provided quality workmanship, employment, and community support for 33 years. The Johnsons were active in St. Mark AME activities, helping folks find housing, and the Northside YMCA. (Photograph c. 1930s, courtesy of Irene B. Goggans.)

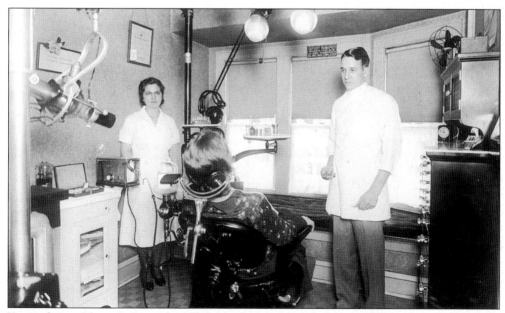

Young dentist Elmer C. Pinter has all the modern technology he can afford in his new office. He graduated in 1928 from Marquette Dental School and had his own office at 3907 North Twenty-seventh Street by 1930. He worked at this address until 1956, when he bought, and moved into, the building at 2501 West Capitol Drive. He operated out of the Capitol Drive office until his retirement in 1975. He poses here with a pliers-like instrument in his right hand. (Photograph c. 1930.)

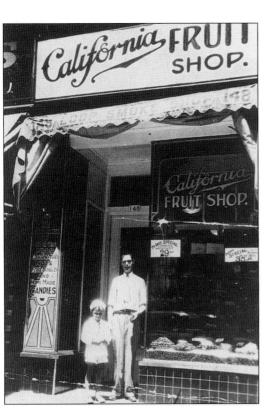

The "California Fruit Shop," in downtown Milwaukee, was owned and operated by Antonio Roca, the first Spanish-speaking retail shop owner in Milwaukee. Born in Majorca, Spain, he lived from age 12 to 17 in Germany. Moving here in 1924, he quickly opened his first of several fruit shops at changing locations. He was successful, but his restless spirit and search for meaning in life led him to join the Bahai faith in 1938 and become a missionary. (Photograph 1935, courtesy of the Arnoldo Sevilla Collection.)

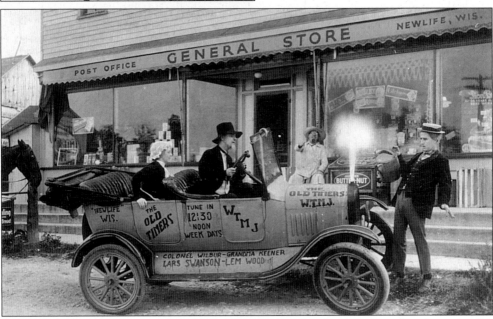

WTMJ radio went on the air in July 1927 at 1,020 kilocycles. In 1928 they were given the 620 kilocycle channel, and they've worked hard ever since. One show was *The Old Timers*, set in the fictional town of Newlife, Wisconsin, and this postcard was a promotional item. Hugh B. Marshall played Colonel Wilbur, and Grandma Keener merely posed for this photograph; she was not on the air. (Photograph c. 1931.)

William A(ugust) Klatte (1872–1944) was the son of a Milwaukee haberdasher. After earning an 1899 University of Wisconsin-Madison law degree, Klatte returned home to practice. When the county replaced justices of the peace with a seven-judge civil court, he wrote to all the judges suggesting that a "Clerk of Civil Court" would be needed. He was appointed to the new position and served from 1910 to 1942, one day before his 70th birthday. (Photograph *c.* 1941.)

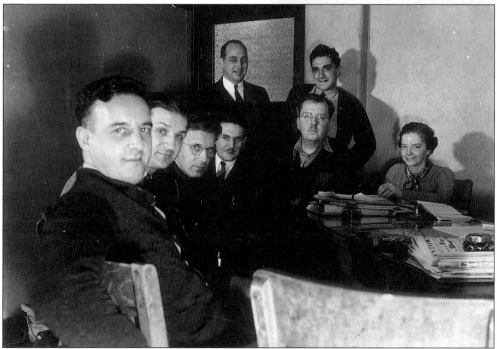

The *Milwaukee Downtown Shopping News* was a weekly newspaper that published from about 1927 to 1941. The staff here are, from left to right, as follows: (seated) Heron Maurer, distribution; Joe Reis, district manager; Bill Stumpf, district manager; Herb Kleist, circulation manager; Ed Seeger, district manager; and Esther Rahn, secretary to the president; (standing) Mr. R.E. Barnett, president and general manager; and Bob Surface, district manager. (Photograph *c.* 1937.)

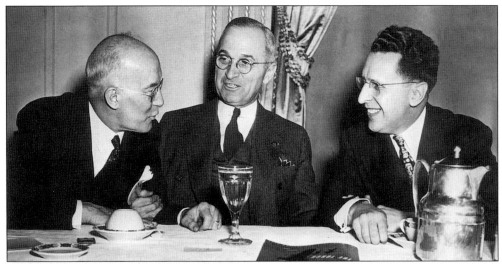

Only weeks after the death of F.D.R., Harry Truman visited Milwaukee. Harry Bell (left), Association of Commerce Executive Secretary, later received this May 1945 letter from Les Hafemeister (right) of Weyenberg Shoe Company, "Dear Harry: Whatever it was you were saying, you had an interesting audience. You can show the attached picture to your friends, relatives, and grandchildren, and prove to them that even the President of the United States hangs on every word you say!"

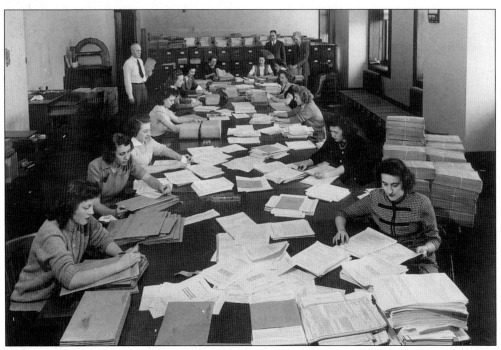

Here in the New Business Issues Department of Northwestern Mutual Life Insurance Co., these women were collating and enveloping new business forms for use with insurance policies. Each envelope would be mailed to one of the company's widespread life insurance agents. Marcella Gromacki, the third lady from the right, began there as a high school senior, but had recently graduated. (Photograph c. 1945, by Louis Kuhli, courtesy of Marcella [nee Gromacki] Makarewicz.)

"Only once, about a month ago, have I encountered another jeep labeled Milwaukee. But mine draws more attention and comments by virtue of the beer steins, therefore I lay positive claim to being our most noted overseas ambassador. Many a GI mouth has watered in reminiscence as it yelled in mock anguish as I passed along the highways of France and Germany. The other gent [left] is Charlie Chapin, now Hq. B.C. Capt. William C. Klatte [right: son of W.A. Klatte, page 27]." (Photograph 1945.)

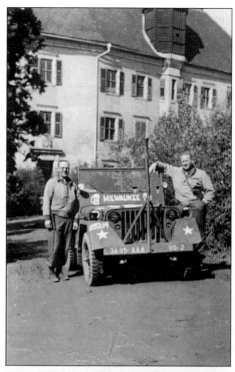

The WEMP engineers monitored performers through the window (note the standing microphone in the other room). WEMP first went on the air around 1935, broadcasting from their studio in the 711 Empire Building, which also housed the RKO Riverside Theater. In 1946, WEMP advertised themselves as "the only radio station in Milwaukee broadcasting Polish music, songs and news since the beginning of its operations 11 years ago." (Photograph c. 1940s(?) by William Spies.)

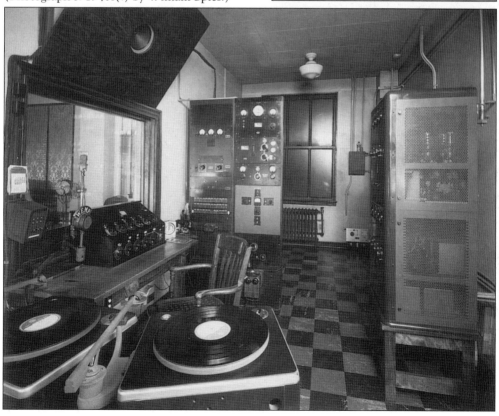

TO: MR & MRS HARRY MAURER

744- SOUTH 28th STREET

MILWAUKEE 4, WISCONSIN

USA.

FROM ASN 36233009

66th Bomb Sq. 44th B.G. (H)

APO# 558, c/o New York, N.Y.

May 9th 1945

PASSED BY 40126 S

ARM EXAMINER

(CENSOR'S STAMP)   SEE INSTRUCTION NO. 2   (Sender's complete address above)

HELLO FOLKS,

RECIEVED YOUR V LETTER AND ENJOYED HEARING FROM YOU, VERY MUCH. TODAY BEING THE DAY AFTER V DAY AND I AM GOING TO DO SOME CELEBRATING. WOULD'NT BE PROPER FOR ME NOT TO COME IN ON THIS CELEBRATION, SEEING THAT I HAVE BEEN OVER HERE AS LONG AS I HAVE. I DID RECIEVE A LETTER FROM ED WITH YOURS AND BEING WRITTEN ON APR. 22nd. I KNOW THAT THE END OF THE WAR HAD FOUND OUR FRIEND AND YOUR BELOVED BROTHER, IN THE BEST OF HEALTH AND REALLY ONE TIRED SOLDIER, WHO HAS DONE MORE THAN HIS SHARE IN MAKING THIS VICTORY, WITH COUNTLESS OF MILLIONS OF HIS BUDDIES, POSSIBLE FOR US BOYS AND FOR YOU FOLKS BACK HOME TO CELEBRATE A COMPLETE VICTORY OVER THE GERMANS.

SPEAKING OF A CLIMAX TO THIS WAR, I ALONG WITH ALL THE BOYS IN THE AIR FORCE WHO WERE SHARING THE OPPORTUNITY OF SEEING THE WORK THAT OUR PLANES HAVE DONE OVER GERMANY. WE WERE ON A TOUR OVER BELGUIM AND GERMANY FOR CLOSE TO SEVEN HOURS AT LOW LEVEL FLYING OVER GERMAN CITIES. WHAT HAS HAPPENED TO THOSE CITIES, SHOULD NOT HAPPE TO ANYONE BUT TO THE GERMAN CITIES. COMPLETE WRECK IF I EVER SAW ONE. JUST DEMOLISHE TO THE GROUND AND THAT CITY OF COLONGE. I DOUBT IF I EVEN COULD WRITE ON PAPER, WHAT I REALLY SAW. ONE CATHEDRAL, WHICH I HAVE SEEN IN MANY OF OUR PAPERS FROM BACK HOME IN PICTURES AND I HOPE YOU CAN RECALL SEEING IT. IS THE ONLY BUILDING I BELIEVE IS STANDING THERE.

WE CAN THANK GOD, THAT WE WHO ARE FORUNATE IN BEING WELL AND ALIVE TODAY, TO CELEBRATE THE CLOSE OF THIS WAR AGAINST GERMANY AND TO SAY A PRAYER FOR ALL OUR BUDD THAT MADE IT POSSIBLE AND ARE NOT HERE WITH US, ON THIS MEMORIAL DAY.

ONLY NOW WITH HIGH HOPE OF BEING BACK IN GOOD OLD MILW. IN THE NEAR FUTURE AND TO RECIEVE SOME OF THOSE HAPPY REUNIONS WITH THE FOLKS AND FRIENDS, THAT WE HAVE WAI FOR SO VERY LONG.

YOUR MILW FRIEND,
ED (kemy)

HAVE YOU FILLED IN COMPLETE ADDRESS AT TOP?

REPLY BY
V---MAIL

HAVE YOU FILLED IN COMPLET ADDRESS AT TOP?

☆ U. S. GOVERNMENT PRINTING OFFICE : 1943  16—28169

During World War II tons of mail were sent via V-Mail. A V-Letter was a one-page letter written on a special form. After mailing, each letter was photographed (many letters on a roll of film), and the film was flown overseas. Each letter was then printed as a reduced-size photograph, which was delivered. Nothing could be enclosed with a V-Letter, but supposedly it was faster than airmail. "V" stood for Victory. The original print of the V-Letter above is 4.25 by 5 inches. (Photograph May 1945.)

## *Two*
# MUSIC, SPORTS, AND SOCIALIZING

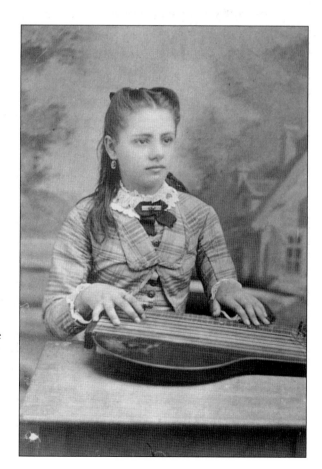

Before radio there were musical instruments, and not just in high schools or symphonies. It was quite common for one or more family members to be musicians. In the nineteenth century, when folks carried a cherished object to the picture studio for a portrait, as often as not, it was a musical instrument. (Photograph c. 1880, by Adam Heeb.)

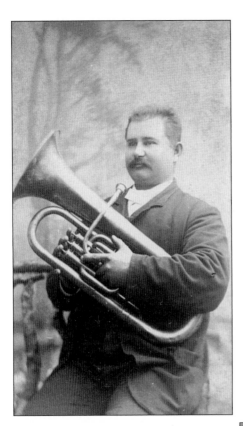

It just seems to me that this young man simply *belongs* with this instrument. (Photograph *c.* 1882 by Adam Heeb.)

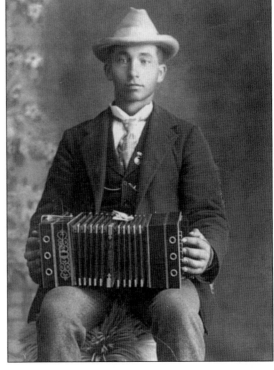

This serious fellow holds an instrument that is quite often found in 1920s and 1930s party photographs, but I have rarely seen one in a single-person studio portrait. The origins of the accordion may be traced back over 2,000 years. This button accordion was much like the accordions of 50 years earlier. (Photograph *c.*1900 by Ferdinand Steinborn.)

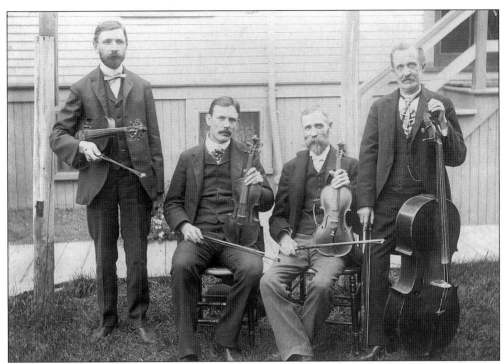

Whether these four gentlemen had a name for their string quartet and hired out for events, or they simply played for their own enjoyment, is unknown. What is known is that the man at the far right was John H. Baumgaertner (brother of Henry, page 107, and father of Gertrude, below). John was a sign painter by trade, but he loved music. I am told he played violin, fiddle, and bass fiddle. (Photograph *c.* 1910.)

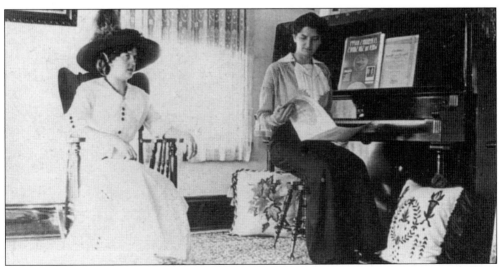

Gertrude S. (nee Baumgaertner) Damrau (*c.* 1899–1983) wasn't just the parlor piano player. An only child, she was often exposed to music through her father. Later Gertie made her living with music. She played piano and organ for silent movies at the Riverside Theater, played at some honky-tonk bars, and played new music on piano for potential sheet music buyers at the downtown Boston Store.

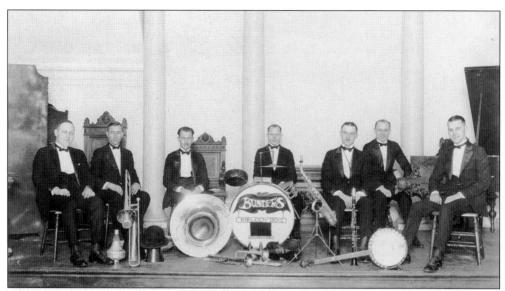

Traditional music in America had included lots of brass bands and classical music. The banjo, invented in the early 1700s by black slaves, had mostly developed its modern form by the late 1800s, and gained increasing popularity with the advent of Ragtime music. We do not know what type of music "Buster's Melody Boys" of Milwaukee played, but they were there for the dawning of the Jazz Age. (Photograph November 25, 1920, by Louis Kuhli.)

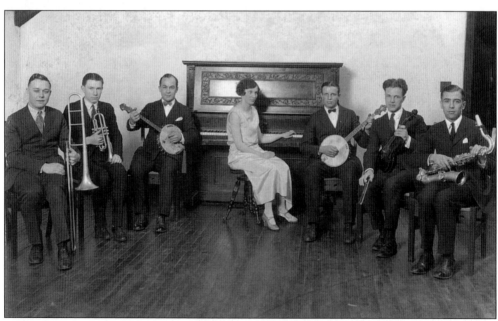

After the Great War (World War I), there was quite a bit of cultural backlash against many of the traditional ways of thinking that had brought on the devastation and economic hardships of world-wide war. Dixieland Jazz started busting loose, and the banjo provided some exciting new sounds in a new age. This group is believed to be State Normal School students (later UW-Milwaukee), mixing in a pair of banjos with traditional violin and brass. (Photograph *c.* mid-1920s.)

Alex Mayr is pictured here as he looked as the young clarinetist who played at the Wisconsin Theater downtown. The city directory of 1923 listed Alex as "instr[uctor] music Marquette Univ." From 1924 through 1931, he was identified simply as "musician." It was during this period that he worked at the Wisconsin Theater, and then in the Strand Theater Orchestra. (Photograph c. 1925, by Harmon Seymour.)

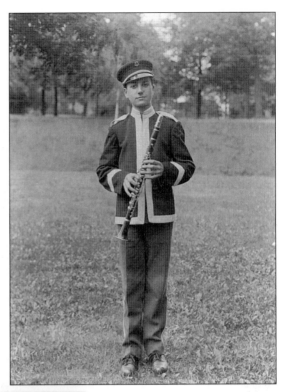

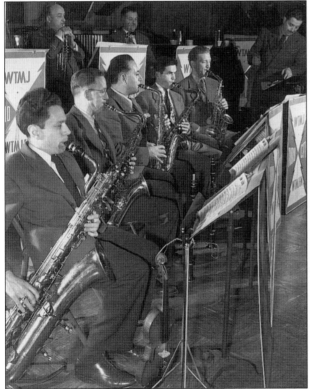

In 1931, Alex Mayr became a regular member of the "WTMJ Radio City" orchestra. In this 1940s photograph, Mayr is the middle saxophone player (clarinet is by his right knee). Being able to play multiple instruments was often important in landing and keeping a paying job. At far right is the band leader, Jack Bundy, famous locally during the 1930s as Heinie, leader of the Grenadiers.

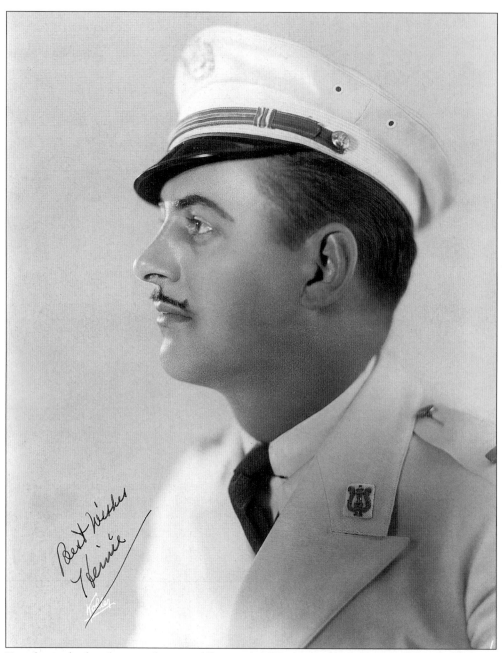

Yes, this is the handsome, vibrant, wildly popular "Heinie," of Heinie and the Grenadiers. At public events he wore his trademark all-white outfit, with dashing white cap—all decorated with musical symbols. The Grenadiers were men from the WTMJ orchestra; not all of them played every time, but there was some flexibility in who might play at different events. I've been told that during the glory days of the Grenadiers, their regularly scheduled WTMJ radio shows drew a huge listening audience, and that when Heinie and the band appeared at a picnic or party around town, nearly every summer weekend, the event was jammed. After leaving WTMJ, Jack Bundy (Heinie) was a regular on a national radio program for a while. After his radio career, he owned and operated a Milwaukee advertising firm. (Photograph *c.* 1936, by Robert Kohler.)

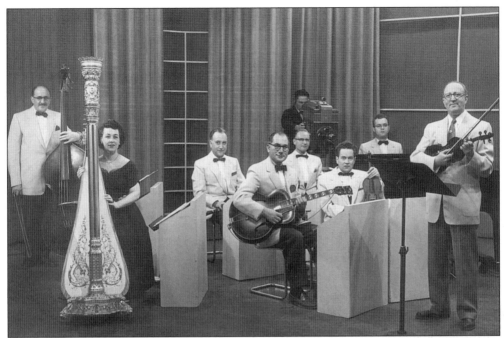

We return once again to Alex Mayr, still playing with the WTMJ orchestra in this 1950s photograph. Now in the WTMJ TV studio, Mayr is seated with clarinet across his lap, to the right of the lady on harp. Alex Mayr remained with WTMJ until at least 1960, ending his career there as an assistant librarian, a less taxing position for this soon-to-be-retired gentleman.

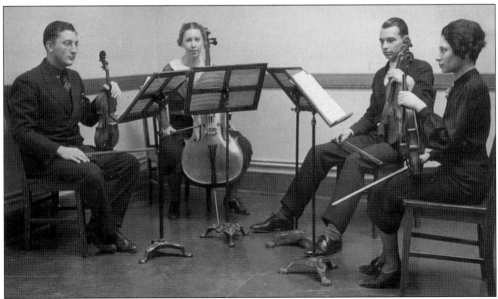

This string quartet was assembled from the 1937 Milwaukee State Teachers College Orchestra. The orchestra was led by Mr. Hugo Anhalt. The musicians here are listed, from left to right, with their orchestra positions, as follows: Gerhard Schroth, violin and concert master; Esther Gruhn, principal cello; Donald Mohr, principal viola; and Sophia Berland, violin. (Photograph 1937.)

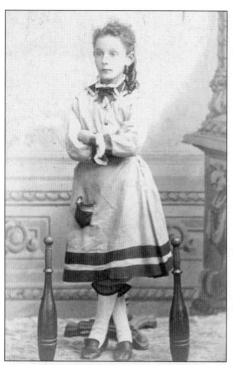

This confident-looking girl with the Indian clubs was probably taking physical culture classes at Turner Hall. The "Turner Verein Milwaukee" became officially organized in 1855, and within five years had erected their own building at Fourth and State Streets. Their motto was "sound mind, sound body," and they offered a range of physical training as well as literary contests and many social events for all members. (Photograph *c.* 1872, by Frank Bishop.)

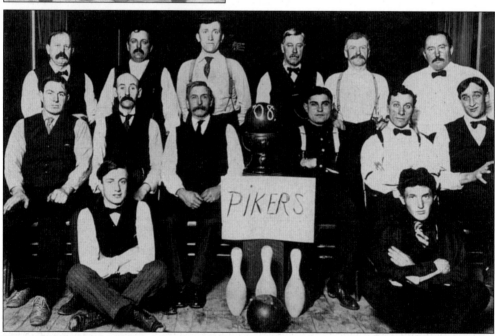

The "1908 Pikers" bowling team was probably in a league; there were dozens of bowling leagues in the city at that time. These men's backs were to the lanes and the "'08" ball is in the talcum bowl. Note the sawdust on the floor. This postcard photo was mailed in June 1909 by Art Rafenstein. Art owned and operated a bar at 1729 State Street from 1907 until 1919. Prohibition drove him into the confectionery business in 1920. (Photograph *c.* 1908, by Harmon Seymour.)

38

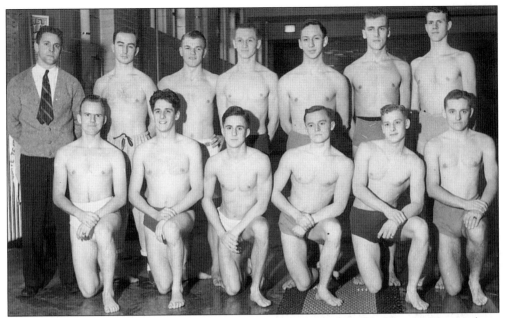

One of the primary organizers of sporting events was, of course, the school system. Here we have the 1937 swimming team of the Milwaukee State Teachers College (later UW-Milwaukee). The Green Gulls had a successful season, winning seven straight meets at one point. Pictured from left to right are the following: (front row) ? Braun, Art Walker, Ralph Pyszynski, Joe Stangl, Art Vierthaler, and Bob Buech; (back row) Coach Kluge, George McCann, ? Rugel, John Schertzel, Dick Piasecki, Clarence Wolff, and Marvin Groelle.

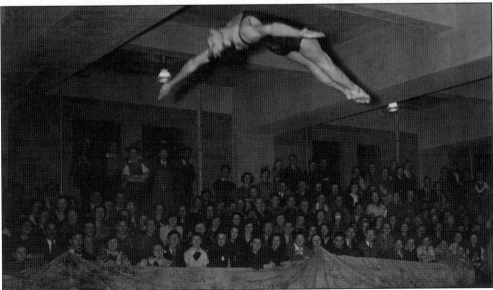

This diving competition also took place in 1937 at the Milwaukee State Teachers College. Note that the unidentified diver wears a long suit with shoulder straps rather than the trunks worn by the swim team above. Also, I can't help but flinch a bit at how close he seems to be to the ceiling. Either diving competitions took a great deal more skill and daring than I thought, or the camera's angle is deceiving.

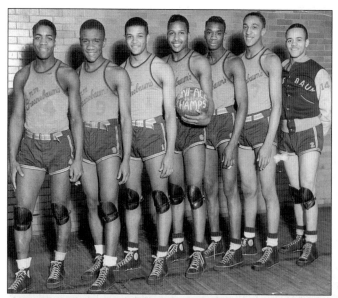

These "1938 Muni-Ace Champs" were, from left to right, as follows: Vernal Britton, Dan Harrell, James Tunstill, James Means, Cliff Stinson, Pat Goggans, and Coach Henry Moore. The Milwaukee Municipal Athletic Association, Department of Municipal Recreation, organized 1,861 amateur teams in 29 sports in 1938. Muni-Ace was the "Super Triple-A League" in basketball. This team was sponsored by Greenbaum's Tannery. (Photograph 1938, courtesy of Irene B. Goggans.)

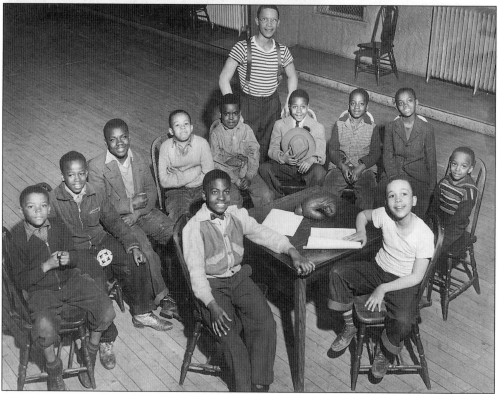

This happy group is the Copper Gloves Boxing Club at the Booker T. Washington YMCA gym at Eighth and Walnut Streets. Athletic Director Mr. Sylvester Sims stands behind the others, who are, from left to right, as follows: (front row) unidentified and Granville Sims; (back row) John H. Givens III, William Clark, unidentified, Bootsie Sims, Purley Clark, unidentified, Lively Lewis, Jay Campbell, and unidentified. YMCA membership for kids cost 50¢ per year. (Photograph c. 1947, courtesy of Irene B. Goggans.)

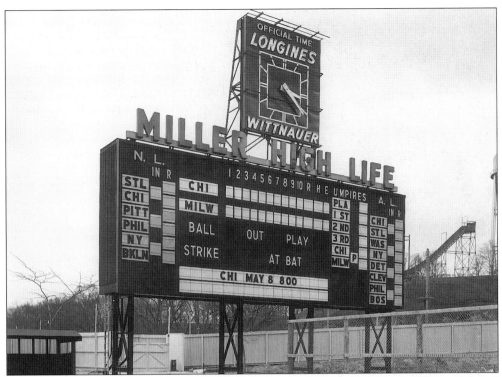

Milwaukee County Stadium was built before the county knew it had a team. This scoreboard was state-of-the-art that spring of 1953, and there were no permanent right-field bleachers yet. Even though the stadium's seating capacity was 36,000, Milwaukee set a National League attendance record of 1,826,397 that first year. When Boston's ball club moved here, it was the first time in 50 years any major league team had changed cities. (Photograph April 28, 1953, by James Murdoch.)

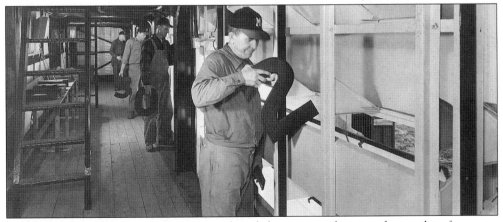

Inside the original Milwaukee Braves scoreboard, four men are hanging the numbers for scores, innings, outs, etc. As a kid, I used to wonder what kind of contraption someone was running inside that board to keep everything current. It turns out it was good old-fashioned elbow grease, applied at several levels. Extra numbers are piled on a narrow table between the ladders. Wagner Sign Co. commissioned these two photographs. (Photograph April 28, 1953, by James Murdoch.)

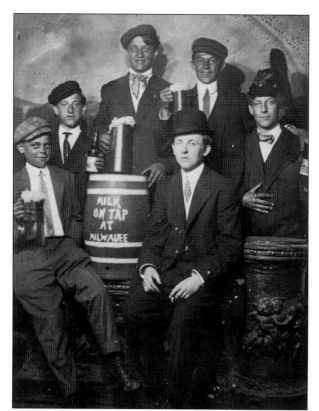

Well, it's a fine June day in 1910 Milwaukee, and what's a guy and his pals to do for some fun? Why, go out and raise a few, of course! This *is* America's beer capital after all, and it is the sociable thing to do. Everybody else does it, don't they? Well, not at this photography studio you don't. The keg may say, "Milk On Tap At Milwaukee," but it's only fluffed cotton on their mugs.

These two young dandies, however, have the real thing—Pabst Blue Ribbon Beer. Pabst Brewing Co. was the Phillip Best Brewing Co. (owned by Fred Pabst's father-in-law) until 1889. Best's "Select" beer had blue ribbons tied on their bottle necks in 1882. When Pabst beat Anheuser-Busch at the 1893 Chicago Columbian Exposition beer competition, Pabst added "Blue Ribbon" to its label two years later in 1895, and also began tying ribbons on their bottles. (Photograph 1902, by Ferdinand Steinborn.)

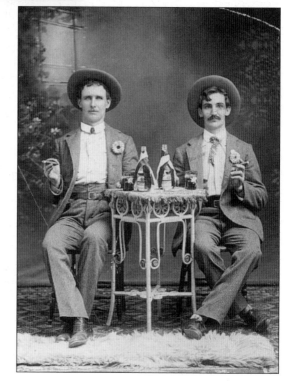

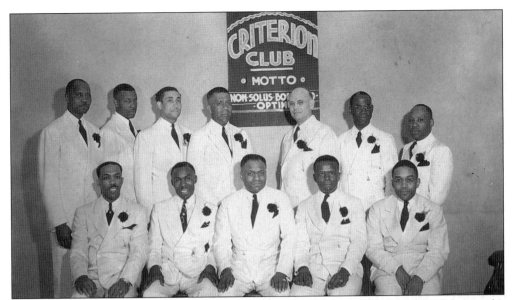

The Criterion Club was a group of friends that organized in 1937 as a savings club in order to fund some useful projects. The men soon converted it to a social club, which added new members occasionally and lasted about 35 years. These members are, from left to right, as follows: (front row) Preston Buckley, unidentified, ? Sizem, Cornelius Oliver, and Herbert Renfro; (back row) Emery Stiles, unidentified, Charles Barnes, George Nelson, Sandle Carter, unidentified, and Eliott Kiff Sr. (Photograph 1939, by Ted Offutt [son of J. Howard, on page 44].)

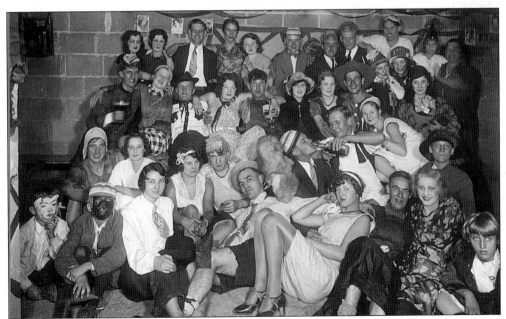

Well, if this isn't a sociable Halloween scene, I don't know what is. This human wave has surged up against somebody's basement wall, and bodies are overlapping up to the modest decorations. Women in men's clothes, men in women's clothes, paper masks tilted up on many a head, and other masks still covering faces are all visible. (Photograph c. 1920s, by Roman Kwasniewski.)

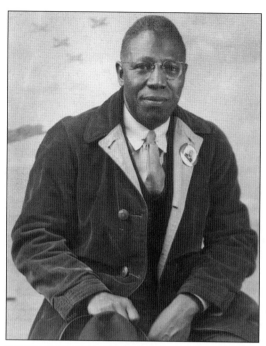

As a youngster, J. Howard Offutt studied violin and piano. Hospitalized WW I soldiers regained confidence when he involved them in singing. In 1928, Professor Offutt (1894–1986) brought his method of healing, hope, and social harmony through music to Milwaukee. "Papa," as he was fondly called, directed the choir at St. Mark AME Church and organized the Coleridge Taylor Singers in 1932, the Urban League Male Chorus in 1934, and the Young People's Chorus in 1936. Music was the method, love was his message. (Photograph December 1942, by J. Harry Taylor, courtesy of the Wisconsin Black Historical Society/Museum.)

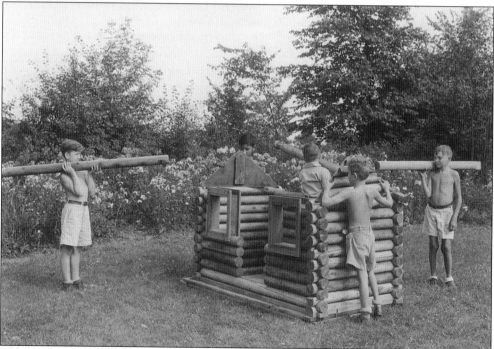

This picture has a kind of comfortable, good-old-days feel to it. A bunch of pals, perhaps neighborhood buddies, seem to be helping one of their group assemble a nifty, pre-cut log cabin. It's good constructive fun. But then I discovered that the commercial photographer was hired for this job by Milwaukee Children's Hospital (Convalescent). Apparently the benefit of healthful, outdoor activity is the point in this photograph. (Photograph September 1935, by James Murdoch.)

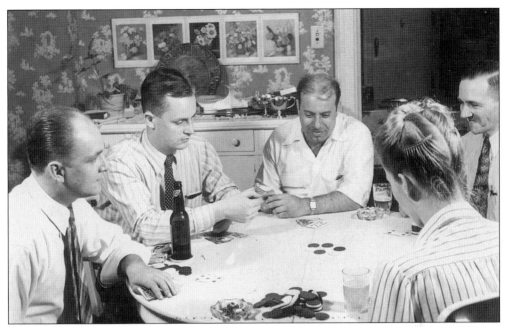

Poker is the game—more specifically here, seven-card stud. The dealer, second from left, has the highest card, a jack of clubs (but we can't see the lady's cards). The woman seems to have the largest pile of chips for now, but the men figure there's plenty of playing time left, so they can still smile. A pack of Camels and a bottle of Schlitz are common game accessories, and a dining room is a perfectly wonderful place to play.

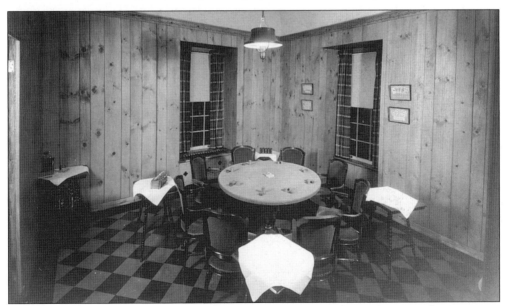

Some people, however, play in more refined settings. This was the card room at the Wisconsin Club, a private club located in the former Alexander Mitchell mansion, at 900 West Wisconsin Avenue. Comfortable wicker-backed chairs and politely draped side tables for drinks and ashtrays stood amid homey, knotty pine walls, decorated with a real Royal Flush and three framed straight flushes. (Photograph November 28, 1942, by James Murdoch.)

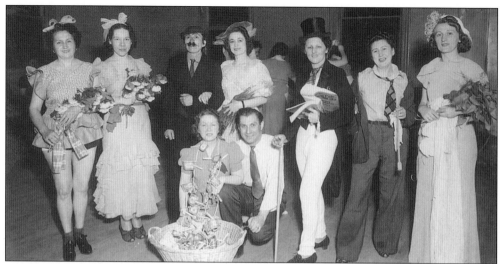

This "Wedding Shower," on "May 26, 1939," has a pseudo-wedding-party theme. The two "man" characters at right hold a telephone book and a back scratcher. I think I get the symbolism of the back scratcher, anyway. The real bride-to-be is cleaning up with a clothesline full of one dollar bills, and even the groom looks happy. (Photograph May 29, 1939, by William C. Sasse.)

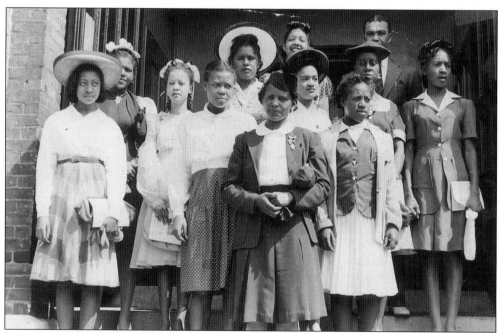

This Sunday school class posed at the St. Matthew Christian Methodist Episcopal Church at 538 West Walnut Street. The church, organized locally in 1918, moved in 1958 to its present location at 2944 North Ninth Street. Class teacher Thelma Rogers is in front. The others are, from left to right, as follows: Dorothy Clemons, Catherine Pettis (superintendent), Clarise Howard, unidentified, Lela Parchman (white hat), Mary Pickford Bishop, unidentified (behind Mary), Bertha Bacon (right of Rogers), unidentified, unidentified, and Harry Gardner (past superintendent). (Photograph 1942, courtesy of Irene B. Goggans.)

# *Three*
# POLISH COMMUNITY PHOTOGRAPHER
## ROMAN B.J. KWASNIEWSKI

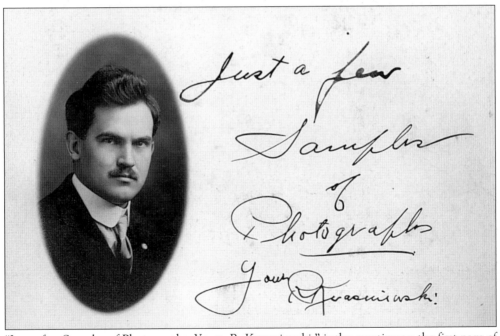

"Just a few Samples of Photographs. Yours, R. Kwasniewski," is the greeting on the first page of a display photograph album created by Roman B.J. Kwasniewski early in his career. Kwasniewski (1886–1980), pictured here with his inked signature, opened his Lincoln Avenue photography studio in 1913. After moving the studio a half block west to a newly constructed building in 1917, he operated his Park Studio until 1947. (Photograph by Roman Kwasniewski.)

The first five pages of this chapter show photographs from Kwasniewski's display album. The 24-page album contained 60 photos that showed potential customers the primary types of photographs shot by the studio. Above we see one display page. Although Kwasniewski never took pictures during a wedding, it was quite common for wedding participants to visit the studio for keepsake photos. (Photograph by Roman Kwasniewski.)

Among the most frequently photographed scenes in studios were Confirmation and First Holy Communion pictures. In fact, Kwasniewski photographed the First Holy Communion picture of young Clement Zablocki, long before he was elected to the United States Congress. The handsome young man at left though, like the other folks on these two pages, remains unidentified. (Photograph by Roman Kwasniewski.)

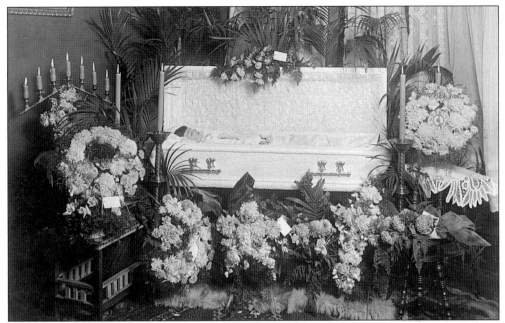

Included in the display album are five photographs of deceased persons. Three of the five are children. We must remember that for the first half of this century, the vast majority of people did not own a camera. Many people never had their picture taken in their lives. So when, suddenly, a loved one passed on, the family very often sent for the local photographer, so that a peaceful remembrance might be obtained. (Photograph by Roman Kwasniewski.)

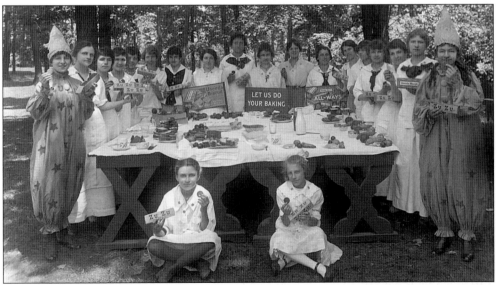

In the late 1800s, some companies offered to give individuals a photograph of themselves if they would wear the company's sign or product in the picture. Maybe this is similar. Everyone here displays a product: "Zu Zu Ginger Snaps," "Uneeda Biscuits," or an advertising sign for the National Biscuit Company (later known as Nabisco). The table is loaded with cookies, biscuits, sandwiches, fruit, milk, and cups. Lunch anyone? (Photograph c. 1920 by Roman Kwasniewski.)

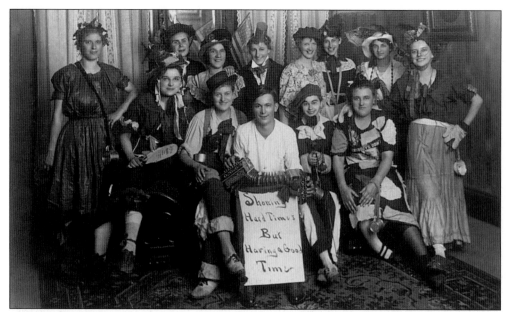

"Showing Hard Times But Having a Good Time" is the theme here. Patched clothing, tin cups hanging from ribbons, oddball items, and old, mismatched clothing are all thrown together, along with a young fella and his button accordion. Hard Times parties were quite popular, as folks entertained themselves to briefly forget their worries. Sometimes the women dressed like men, but more frequently the party-goers wore silly, made-up costumes. (Photograph by Roman Kwasniewski.)

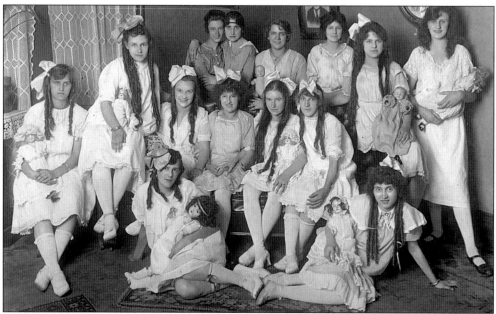

This doll party theme seems to include the young ladies too. Most are dressed in doll-like finery. It is interesting to see the various dolls and their outfits, but to a doll collector, I imagine, this photograph is a tease. They can't really tell the quality, color, or nature of each doll's head, eyes, body, wig, or clothing. (Photograph by Roman Kwasniewski.)

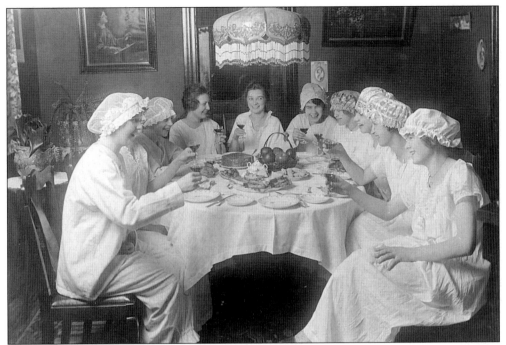

What's a sleep-over party without a light supper first? Apples, sandwiches, cookies, and cake are spread below a wonderfully beaded, hanging lamp. Perhaps the photographer even suggested that the girls make a toast, telling them to imagine that their tea (apple juice?) is really red wine. Giggles, smiles, SNAP! (Photograph by Roman Kwasniewski.)

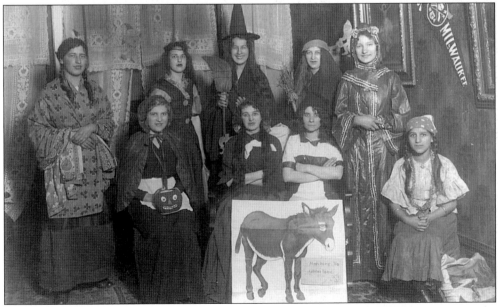

I really get a kick out of this Halloween party photograph. The homemade costumes, the obviously happy Witch of the South, and the donkey with his tail securely pinned on—all are "Marching to Ghostland." Looks like those ghosts are in for a fun party. (Photograph by Roman Kwasniewski.)

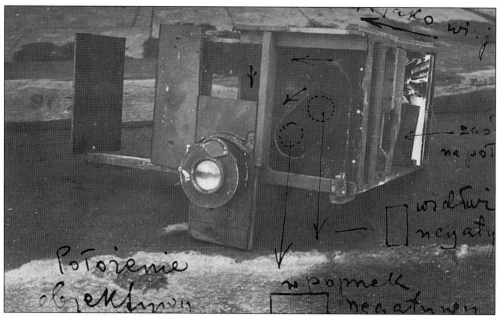

Early in Roman Kwasniewski's career, he experimented with making his own photographic equipment. On this page are two photo postcard images (of six known) of some of his homemade apparatuses. Although they are very rough in design, I believe he did use some of his inventions in his business. I don't know why he wrote descriptive notes on these photographs. (Photograph c. 1914, by Roman Kwasniewski.)

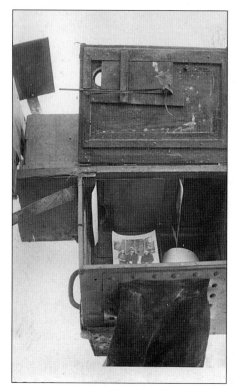

Kwasniewski seemed to have a knack for inventing devices to solve problems. Over the years he created a typewriter with a light bulb, in place of the return bell, for his elderly, deaf father; he refined a method for straightening scrap wire for his mother's artificial flower business; and he helped design a glass vent needed in processing metal plating for his son-in-law. (Photograph c. 1914, by Roman Kwasniewski.)

Although Park Studio's business was mostly family events, individual portraits, or religious subjects, Kwasniewski was always available for commercial photography. Here is a product display picture of a large radio produced by the Lincoln Radio Mfg. Co., actually the Marian Szukalski & Son company. Their hardware store, at 1412 Lincoln Avenue, operated until at least 1960. I did not find Lincoln Radio Mfg. listed in the city directories. (Photograph December 1924, by Roman Kwasniewski.)

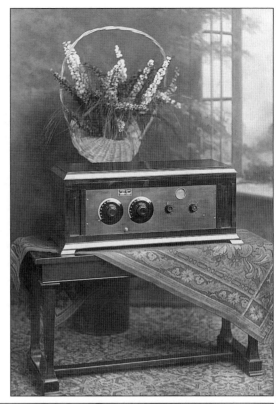

F.W. Woolworth's store at 1229 West Lincoln (1926–1956) really did sell things for 5 and 10¢. In this Easter basket and bunny-laden counter display, all these items cost only 10¢ each: "1/2 yard curtain material, 1/2 yard Artificial Silk Bullion Fringe, Boudoir Cap, Baby Pants, Childrens Bloomers, Brassiere, Infant Bib, Infants Fine Ribbed Hose, and Mens Neckwear." (Photograph by Roman Kwasniewski.)

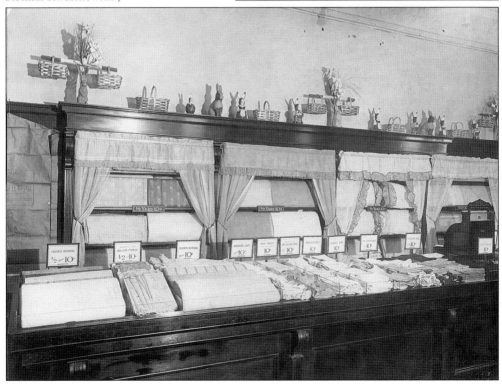

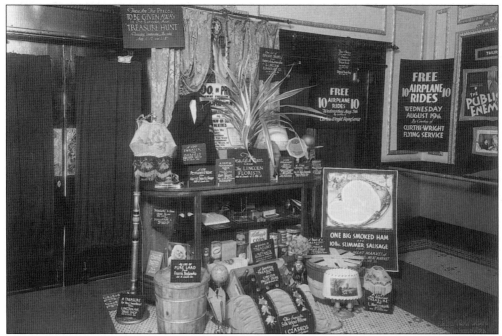

Presenting now, for your enjoyment, the "Treasure Hunt Display" in the lobby of the Riviera Theater at Tenth and Lincoln. A promotional event outside the theater featured four flashy new convertible autos, each with a pair of pretty girls. A large sign proclaimed, "See All These Bathing Beauties on the stage of the Riviera Monday Aug. 10th." The film was *Public Enemy*, with Jimmy Cagney and Jean Harlow. (Photograph August 9, 1931, by Roman Kwasniewski.)

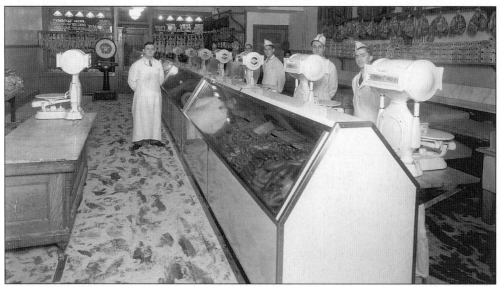

This is Frank Bzdawka's Meat Market. Frank began the business at 1021 Seventh Avenue in 1909, but by 1911 he had moved to this location at 582 Lincoln Avenue (about Eleventh and Lincoln since the city's 1931 street numbering change took effect). The shop prospered for many years after Frank's death in the early 1940s. Frank Bzdawka, at left, was active in, and contributed to, patriotic and political activities. (Photograph by Roman Kwasniewski.)

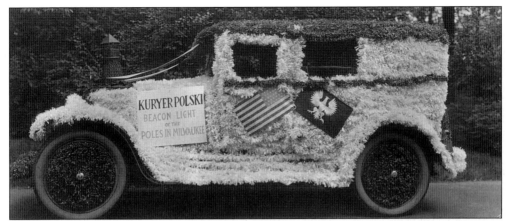

*Kuryer Polski* (1888–1963) was the first Polish-language daily newspaper in the United States. Polish native Michael Kruszka founded the paper to inform, and to advance the welfare of, Polish immigrants in Milwaukee. *Kuryer Polski* also pushed for Polish language instruction in public schools, improved standards in parochial schools, and Polish representation in the local church hierarchy. This led to the creation of *Nowiny Polskie*, an alternate newspaper established to promote the Archdiocese's views. (Photograph by Roman Kwasniewski.)

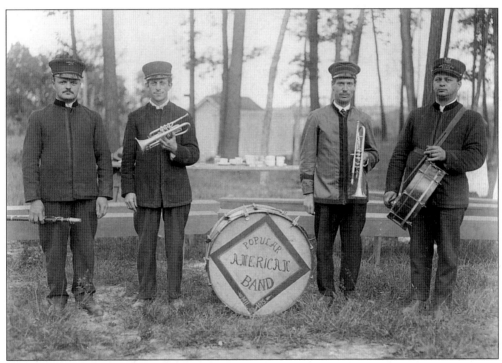

The "Popular American Band, Mil., Wis." was playing at some local outdoor party. I like their hopeful band name, but apparently they weren't quite popular enough to buy matching uniforms and hats. But I bet they had a good time livening up parties and picnics. (Photograph c. 1914, by Roman Kwasniewski.)

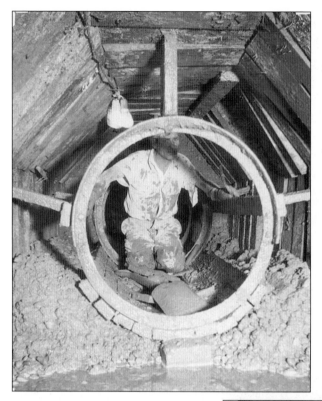

These two pictures provide a new appreciation for the term "working-class laborer." Thousands of Polish immigrants were uneducated peasants with little choice but to accept whatever job was available. Try to imagine yourself working in this man's place—always wet and chilly, always cramped for space, with poor ventilation and bad lighting (not this bright photography lighting). Add in caustic concrete splashes to the face, and you will soon think that a noisy, repetitive factory job looks pretty good. (Photograph by Roman Kwasniewski.)

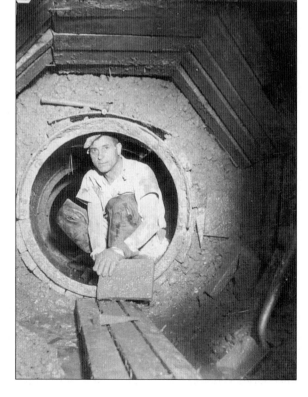

These photographs are also interesting because they show how earlier underground tunnels were created without modern machinery. This unidentified laborer may have been employed by Milwaukee Sewer & Construction Co. in the 1920s. Owned by Walter J. Lazynski Sr., the firm was renamed W.J. Lazynski, Inc. in 1930, when Walter Jr. joined the business. Throughout the 1930s and early 1940s, they constructed sewers, water mains, and surface buildings in five Midwest states. (Photograph by Roman Kwasniewski.)

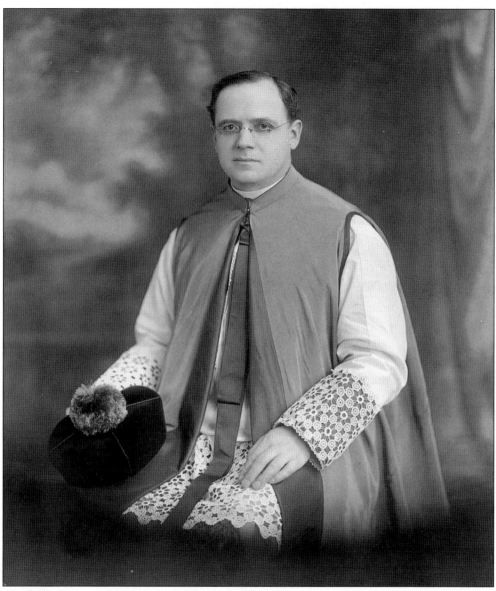

The Right Reverend Monsignor B(oleslaus) E(dward) Goral (1876–1960) began his very busy working life in 1899 as professor and Polish/English literary translator at St. Francis Seminary. In December of 1906 he founded the Polish-language newspaper, *Nowiny Polskie* (Polish News), and labored as its editor and publisher until 1926. According to a March 31, 1928 *Milwaukee Sentinel* article, Msgr. Goral sold controlling interest in the newspaper that year to real estate man Louis A. Fons for about $50,000. Returning to Father Goral's early years, he was the pastor of St. Vincent de Paul Church in 1908, until his transfer in September 1909 to be pastor of the St. Hyacinth Congregation, where he served actively and ably until his death. Also in 1909, he became the Executive Secretary, responsible for management of St. Adalbert's Cemetery, which served all Polish parishes. During his tenure there, he expanded the cemetery grounds from 45 to 103 acres and implemented many physical improvements. Msgr. Goral also sat on the St. Francis Seminary Board of Trustees and served on the Diocesan School Board, among other duties. (Photograph *c.* 1921, by Roman Kwasniewski.)

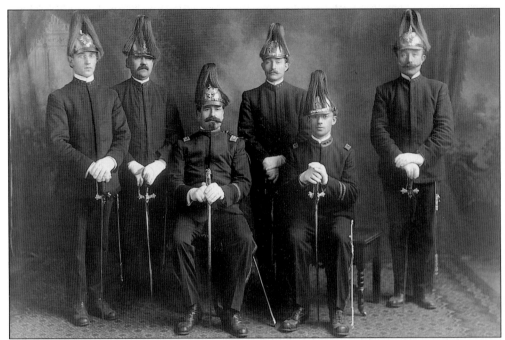

The members of St. Hyacinth Congregation, on the northeast corner of West Becher and South Fifteen Streets, organized many religious, social, and fraternal societies since the parish's founding in 1883. Many of the societies provided valuable support and services to the church and its pastors. One such group is represented by the Honor Guard above, members of the St. Augustine Society, which was founded in 1890. (Photograph *c.* 1915, by Roman Kwasniewski.)

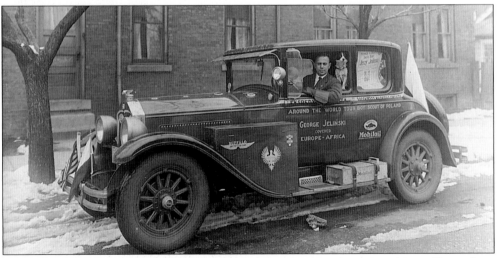

Roman Kwasniewski occasionally shot pictures of important or interesting visitors. Young Jerzy Jelinski, of Warsaw, visited Milwaukee on March 28, 1928. His self-proclaimed *Around The World Tour Boy Scout of Poland* had already traveled Europe and Africa before reaching the United States. This Buick (?) sports emblems for "Mobiloil," "Buffalo—The Queen City," "A.A.A. of Cleveland," as well as the Polish falcon. Roman Kwasniewski was active with the Boy Scouts of America for several years. (Photograph by Roman Kwasniewski.)

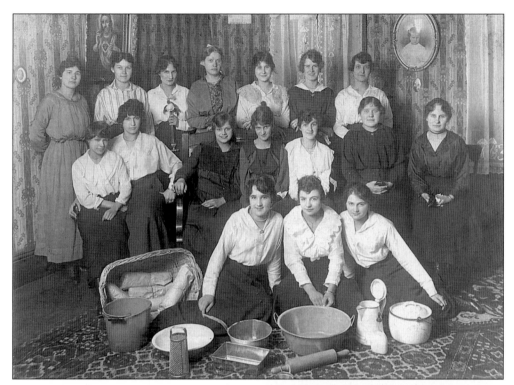

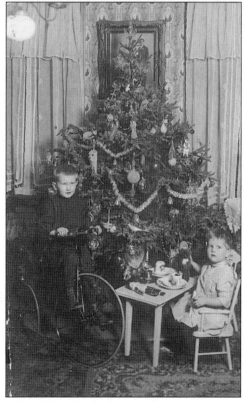

The plain simplicity of these bridal shower gifts is interesting—a pail, a grater, a rolling pin, a bread pan. The times were not fancy, so neither were the presents. Pictured from left to right are the following: (front row) Pauline Tutkowski, Rose Igielski, and unidentified; (second row) Helen Igielski is fourth from left, and Catherine Igielski is fifth. All the others are unidentified. (Photograph c. 1915, by Roman Kwasniewski.)

Professional photographer Kwasniewski seems to have taken very few photographs of his own family. Here is one of my favorites. Roman and Mary (nee Drozniakiewicz) were the parents of three children. These are the two oldest, Edward and Adele Kwasniewski. Roman L. was probably not born yet. Several years ago, I used a copy of this photograph as the front of a personal Christmas card I mailed to family and friends. It was quite popular. (Photograph c. 1916, by Roman Kwasniewski.)

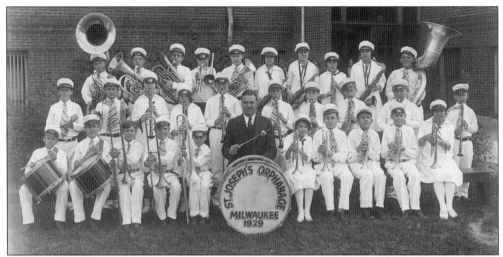

The St. Joseph Orphan Asylum came about because Milwaukee's Polish community, consisting of 17 parishes in 1907, had no orphanage. Polish orphans were sent to Polish orphanages in other cities. Msgr. Hyacinth Gulski shepherded the local orphanage concept into reality, and it opened in May 1908. The senior band, formed in 1929, regularly played at festivals, civic events, picnics, and parades. In 1931 they won a state-wide band contest. (Photograph July 2, 1930, by Roman Kwasniewski.)

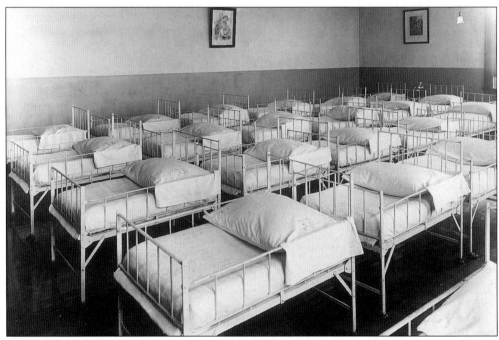

The orphanage's grounds extended from South Eighteenth Street to South Twentieth Street, and from West Euclid Avenue to West Ohio. Three buildings were eventually erected—the primary congregate building, a rectory, and a warehouse. Separate dining rooms in the basement seated boys in one, girls in the other (140 in each). An auditorium seated 650, and the chapel seated 265. This very plain dormitory room slept at least 30 children. (Photograph c. 1930, by Roman Kwasniewski.)

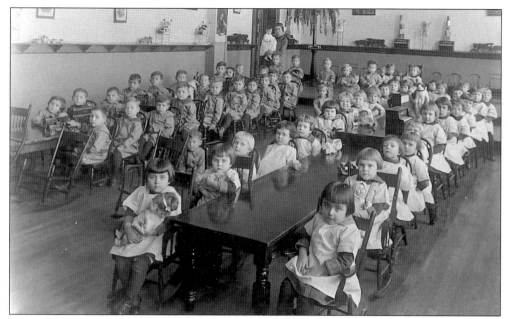

Most of the nearly 60 kids in this room each have a toy—dolls, toy pianos, toy cars, or other play things. Resident children at St. Joseph's were from 3 to 16 years old. New children, often previously neglected or disabled, were provided with the basics of life, plus a parochial school-like education and decent health care. Additionally, the girls were taught the domestic arts, and boys learned carpentry, painting, tincraft, and wood carving. (Photograph *c.* 1930, by Roman Kwasniewski.)

From 1908 to 1946, the tiled and wooden floors of St. Joseph Orphanage felt the pitter patter of over 2,500 children's little feet. The wonderful 1946 book, *We, the Milwaukee Poles,* by Thaddeus Borun and John Jakusz-Gostomski, states that 224 children were residing at St. Joseph's that year, "including the 34 Polish refugee orphans recently arrived from Santa Rosa, Mexico." The orphanage closed in 1972. (Photograph *c.* 1930, by Roman Kwasniewski.)

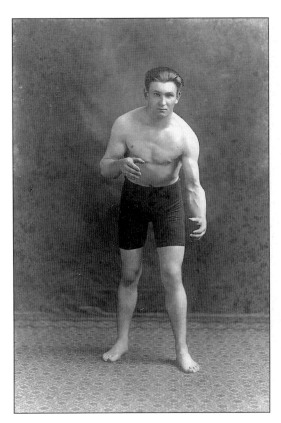

This unidentified wrestler is leaner and meaner than I was in my long-ago wrestling days. Other than foot racing, wrestling may be the oldest organized sport in the world. It was popular with the Egyptians over 5,000 years ago. The Greeks learned from the Egyptians, Romans from the Greeks, British from the Romans and, much more recently, we Yanks got it from the Brits. (Photograph c. 1914, by Roman Kwasniewski.)

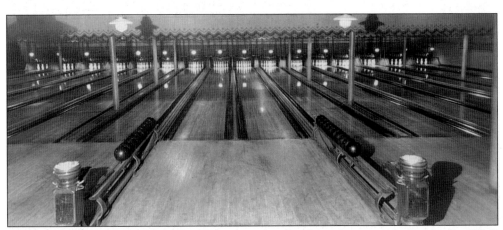

Throughout the early decades of the 1900s, many bowling leagues were sponsored by the Polish National Alliance, the Polish Association of America, the Polish Roman Catholic Union, and the Polish Falcons. This 16-lane hall had many cloth panels hanging across the lanes for decoration and, probably, as sound buffers. The country's first National Bowling Championship Tournament occurred in January 1901, almost three years before baseball's first World Series. (Photograph by Roman Kwasniewski.)

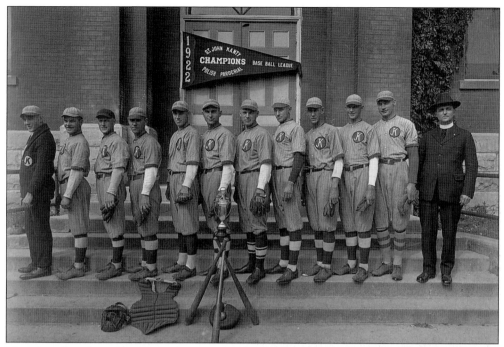

Here is a fine, heart-warming photograph of the "St. John Kanty 1922 Champions [of the] Polish Parochial Base Ball League." The rightfully proud-looking Father Theodore Lass appears to have been the team's coach. St. John Kanty Church opened in December 1907, and the grade school shortly thereafter. (Photograph 1922, by Roman Kwasniewski.)

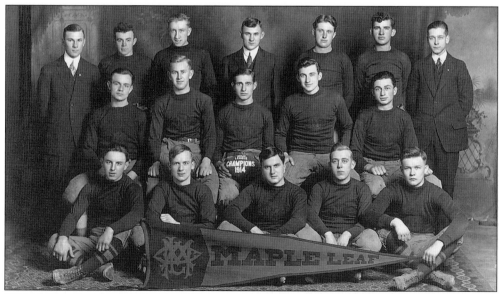

"1914 Milwaukee League Football Champions." Notice that there are only 15 players on this team, when 11 play in a game at one time. It was only in 1910 that the seven-man front line was instituted. Before then, teams pushed forward in any sort of mass—pulling, punching, and kicking whatever opponent was close. It was more like rugby than football. New rules in 1910 encouraged open running and pass plays. (Photograph 1914, by Roman Kwasniewski.)

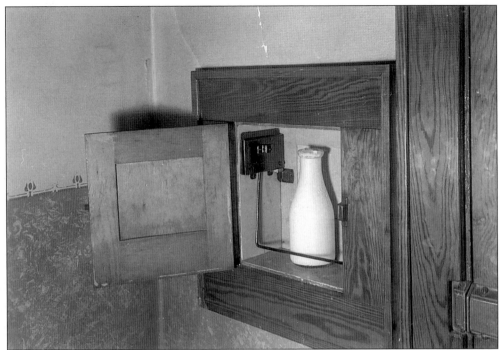

I don't know why this milk chute picture was taken. That metal device was before my time—perhaps Roman invented it? Whatever the reason, this picture speaks to me about an era. It revives that vague "good old days" feeling. It reminds one of simpler times, when milk men and doctors visited folks' homes, when wars were more clearly good vs. evil, and when we were children and milk chutes might be as much fun as an empty cardboard box. (Photograph by Roman Kwasniewski.)

Roman B.J. Kwasniewski, an only child, shared space in his Park Studio for 15 years with his mother's artificial flower business. When Wanda died in 1932, Roman continued her business, even after he retired from photography in 1947. Everything from his photography business simply remained stored in his basement and attic until after he moved to a retirement home in the 1970s. The UW-Milwaukee Urban Archives maintains the Kwasniewski photography collection. (Photograph c. 1946, by Roman Kwasniewski.)

*Four*

# PLANES, TRAINS, AND BOATS

Orville and Wilbur Wright made history by making the very first powered, sustained airplane flight in 1903. American imaginations soon soared, and one unidentified Milwaukee photographer found his own commercial angle. This c. 1907 photograph shows an early bi-plane, mostly painted onto a Milwaukee River backdrop of the Wisconsin Avenue bridge and City Hall. A raised wooden framework, shaped like the plane's structure, allowed the fearless couple to appear to be flying.

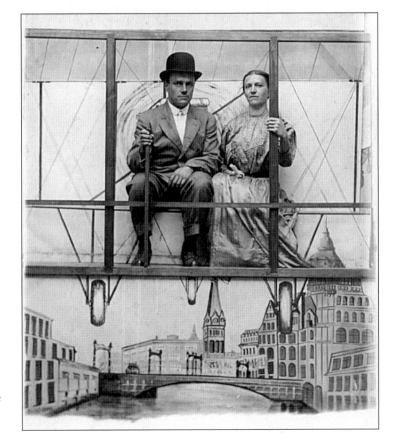

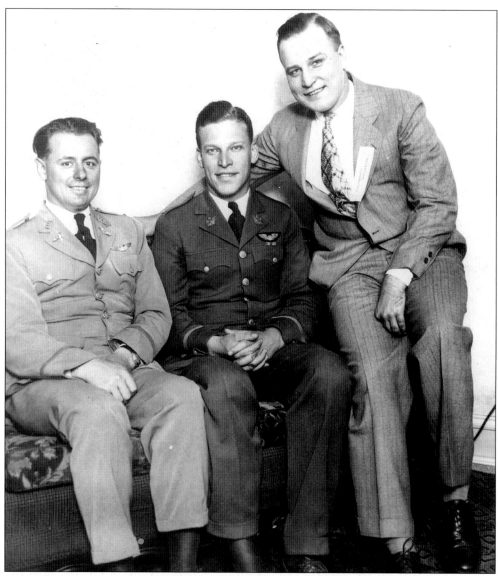

Milwaukee native and Riverside High graduate Lester J. Maitland (1899–1990, center) was the first pilot to fly from California to Hawaii. Maitland had joined the Army Air Service in 1917. In 1919, the Army refused his first Hawaii flight request. Not long after that, he became General Billy Mitchell's aide. In 1926 the Army bought a Fokker Tri-Motor monoplane, and Maitland realized this was the best airplane for his dream flight. He received permission to attempt the first Hawaii flight. To locate the islands in the vast Pacific Ocean, the Army's top navigator, Lieutenant A. Hegenberger (left), would take along half a dozen modern navigational instruments. They all failed during the flight. After a nearly 26-hour fight with the elements, however, the men landed safely on Oahu on June 28, 1927—just 38 days after Lindburgh reached Paris. Maitland now held the record for flying the longest distance over water, non-stop. A month later, Milwaukee named its downtown airport Maitland Field (where Summerfest is now held). He was a general in WW II, then the Wisconsin Aeronautics Commission's first director, and later he became an Episcopal priest. Lester's brother is at right. (Photograph July 19, 1927, by Elmer Richardson, courtesy of George A. Hardie Jr.)

Mrs. Henry Andrae wears the latest woman's flying outfit. Her husband was the vice president of Westinghouse Electric Supply Co., and they lived on the east side's fashionable Terrace Avenue. The shiny, clean bi-plane was a Boeing 40-B-4, flown out of Chicago by one of the larger airlines. It was most likely under contract to deliver U.S. mail here, along with other package freight, but it also carried paying passengers. It seated two in the front cockpit. (Photograph c. 1932.)

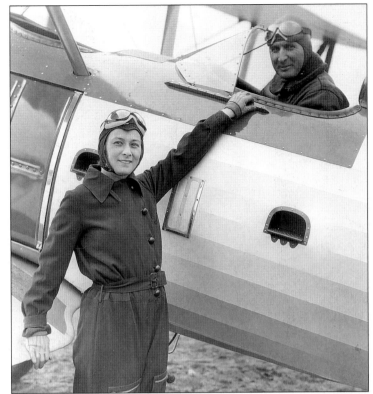

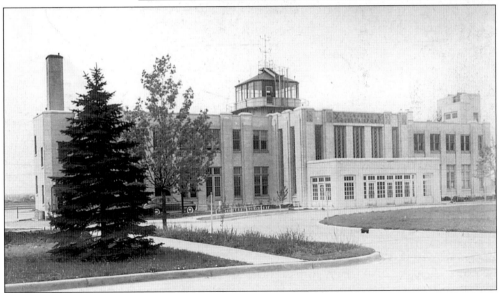

This new "Milwaukee County Airport" administration building was opened on July 1, 1940, on Howell Avenue. The previous administration building had been a converted farmhouse, which stood in the grassy plot just in front of this building. The new building had not only a modern control tower, but offices for the airport, the airlines, the weather bureau, and other government agencies. New customer conveniences included a passenger lounge and restaurant. (Photograph 1941.)

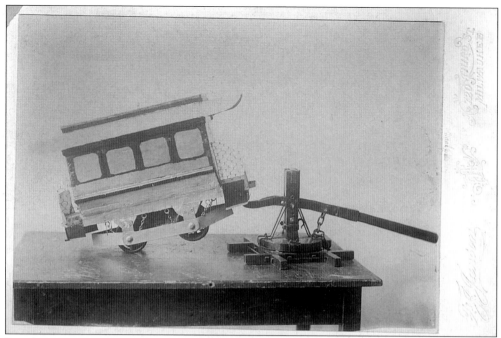

Rapid transit in nineteenth-century Milwaukee meant horse- or mule-drawn transportation. The cars were usually pulled by a pair of animals, and the driver, dressed for the weather, stood on the front platform. Horsecars operated on regular routes throughout the 1870s and 1880s. This tabletop model, which closely resembles a horsecar or the first electric streetcar, seems to be the subject of a mechanical lift test. (Photograph c. 1894, by Fred Janson.)

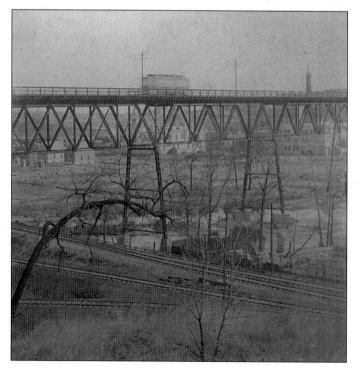

Milwaukee's first electric streetcar had been tested in 1887, but many years of difficulties and development were experienced before reliable service was established. Looking northeast, this is the Wells Street viaduct (in regular service 1892–1958), with an electric streetcar moving too fast for this camera. Imagine "flying" along this narrow bridge in one of the early, rickety streetcars. (Photograph 1904.)

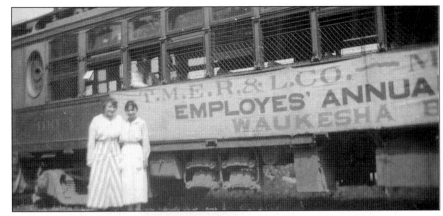

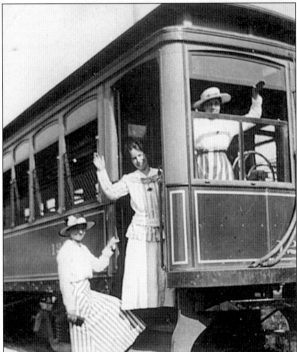

The Milwaukee Electric Railway & Light Company (T.M.E.R. & L. Co., predecessor of the Wisconsin Electric Power Co.) was incorporated in 1896. "TM," as the firm soon became popularly known, rapidly expanded its rail lines and electric power lines to new areas, and by 1909 TM's "interurban" railway lines reached Burlington, Watertown, and Sheboygan. Waukesha became a regular stop in 1898. The Waukesha Beach station soon began drawing large numbers of visitors in the summer time, and Milwaukee firms rented entire trains to carry employees to their company picnics at Waukesha Beach. These snapshots of three unidentified friends provide a glimpse of the cars during TM's own annual picnic ride to Waukesha, as well as a look at the Muskego Center station.

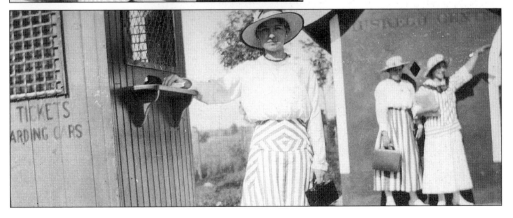

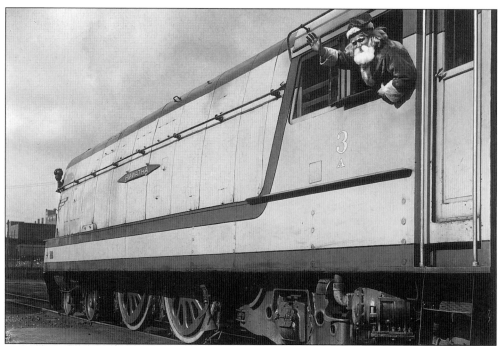

The Milwaukee Road wanted a faster, more attractive train. They developed the *Hiawatha*. Introduced in 1935, the sleek, attention-grabbing steam train quickly began breaking speed records. The colors were a black top, light-gray sides, a maroon stripe below the running board, then Milwaukee Road orange, and another maroon stripe at bottom. Above is the No. 3 engine, which ran mostly between Chicago and Milwaukee or Chicago and Omaha. (Photograph November 1938, by James Murdoch.)

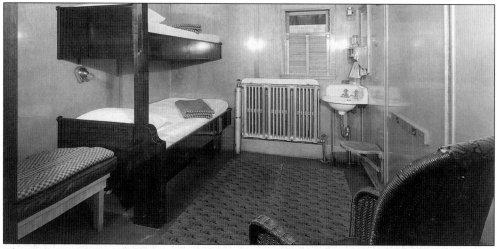

The Pere Marquette Railway Company's two ships, the *City of Saginaw 31* and the *City of Flint 32*, provided decades of scheduled service between Ludington (Michigan) and Milwaukee, Manitowoc, and Kewaunee, Wisconsin. They carried passengers, autos, and railroad cars. This stateroom is better than some others. They advertised a stateroom that looked like this, but was 3 feet narrower and had no chair or bench (left). (Photograph October 1937, by James Murdoch.)

Here, in 1903, the tugboat *W.H. Simpson* commanded by Captain John Driscoll is towing the cargo schooner *E.B. Maxwell* out of the Milwaukee harbor. The Milwaukee River, up to Humboldt Avenue, had been a major Great Lakes cargo destination since the Civil War. Wheat, copper, lumber, coal, and salt beef were but a few of the important products received or shipped.

According to the library's Herman G. Runge Collection, the *Nevada*, built in Manitowoc in 1915, had extra strong, steel hull plates for winter navigation. Sold in 1917 to the Russian government, she was renamed *Rogday*, but supposedly never made it to Russia. Pere Marquette Co. brought her back and renamed her in 1921, and in 1935 her passenger cabins were cut away to the lower deck, so she could carry more autos and trucks. (Photograph November 1937, by James Murdoch.)

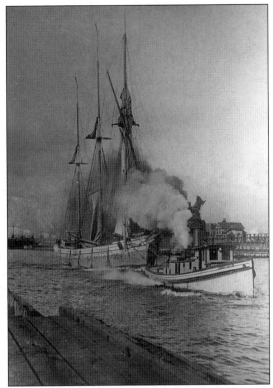

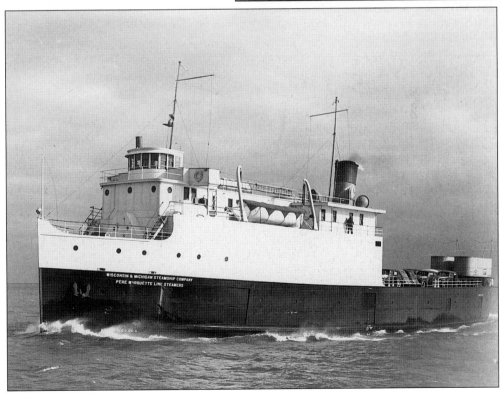

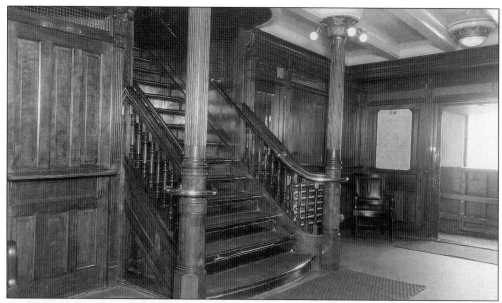

The following four photographs are rather rare interior scenes from a Great Lakes passenger ship. This first is the main entryway of the ship *Missouri*, built in 1904 in Chicago and owned from 1930 to 1933 by the Wisconsin & Michigan Transportation Co. Passengers entered at right, passed the Wisconsin map, and probably checked in on the other side of the stairs. The dutch door at left is brass-labeled as "Baggage Room." The fancy stairway leads to a lounge. (Photograph 1930, by James Murdoch.)

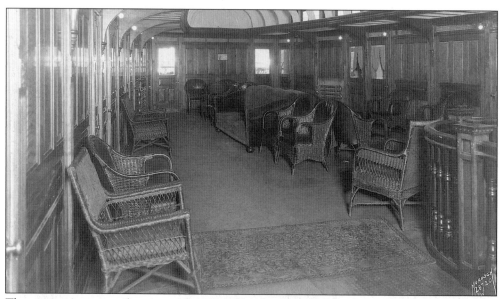

The stairway's upper railing is at right. Note that the ship's dark, rich woodwork carries through to this upper level, as it does through the following stateroom and dining room. The *Missouri* was a passenger ship and packaged-freight carrier that provided regular service between Milwaukee and Michigan. This lounge was a popular relaxing, visiting, and, occasionally, dancing area. Both sides of this room have doors to the passengers' staterooms. (Photograph 1930, by James Murdoch.)

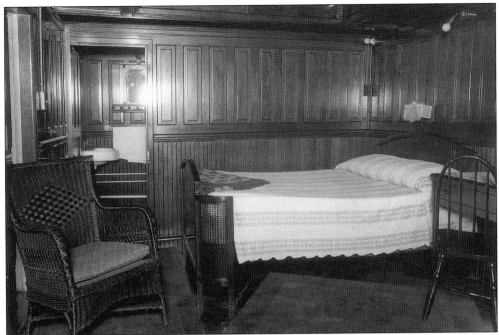

This *Missouri* stateroom had its own washroom with a sliding door (don't know about a bath or shower, though). The wicker chair is the same as those in the lounge, and small skylight windows are common in both areas. The *Missouri* had a steel hull, was 225 feet in length, and suffered a serious fire in 1939 while the ship was laid up. She was scrapped in 1947. (Photograph 1930, by James Murdoch.)

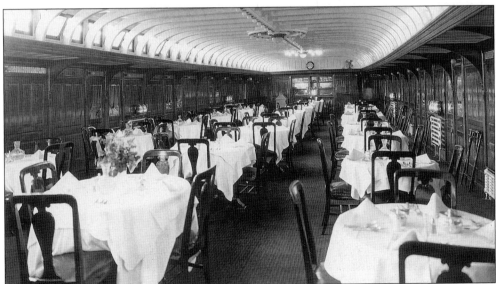

The *Missouri*'s dining room was also on the upper deck (note skylight windows). Women wore dresses and, often, hats to dinner, while the gentlemen wore suits, ties, or sport jackets. They were all attended to by white-jacketed waiters, who also wore ties. Mirrored cabinets for clean glasses and other supplies, as well as a clock, a fan, a tall waste container, and a fancy brass cash register, are visible at the far end of the room. (Photograph August 1933, by James Murdoch.)

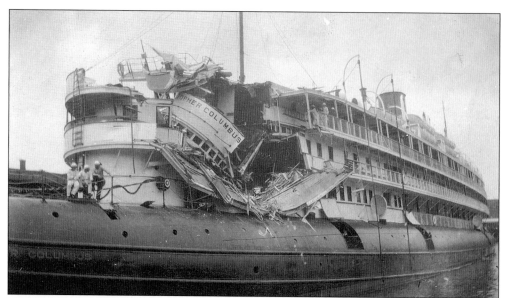

The *Christopher Columbus* was a whaleback steamer built in 1893 for the Chicago Columbian Exposition. It made frequent trips between Chicago and Milwaukee after the Exposition ended. On June 30, 1917, a strong Milwaukee River current slammed the boat's bow into the steel supports of a warehouse's 100-foot-high water tank. The tank collapsed onto the boat, killing at least 14 passengers and injuring 20. The boat resumed service in 1918.

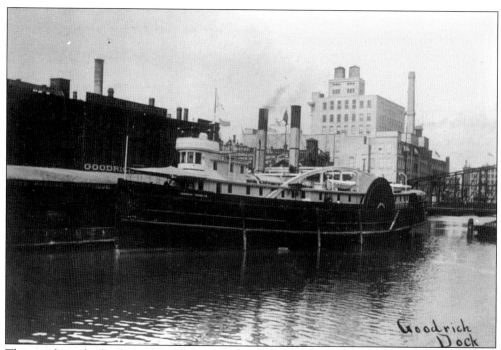

This is the sidewheel steamer *Sheboygan* at the Goodrich Transport Line's dock on the Milwaukee River in 1904. The Goodrich Line was a big name in Great Lakes transportation, handling passengers as well as tons of package freight in the days before widespread trucking was available.

*Five*

# ONE MILWAUKEEAN'S LIFE IN PICTURES

## MARSHALL CAIN

Marshall Cain was just a regular guy who saved his interesting pictures. His photographic life story begins with this 1913 postcard, which 19-year-old Marshall and his brother Delmore mailed from San Francisco. Marshall wrote home to his mom on North Thirty-fifth Street, "Hello Dears— We arrived safe and sound. We are seeing the sights. San Fran. is a large town. We are going down to the coast this morning to see the big boats. Write to us. M. & D. Cain."

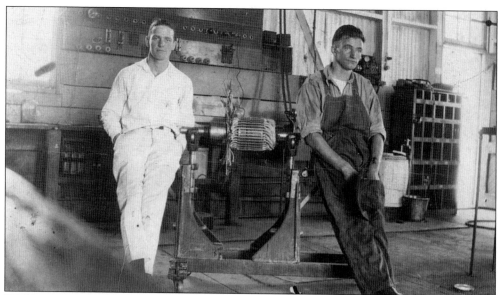

Within two years, Marshall's parents, George F. and Cornelia Bevier Cain, moved to Prescott, Arizona, due to Cornelia's asthma. Marshall also moved and started a business in Phoenix, winding the wires for, and building, electric motors. Marshall (at right) was learning the fundamentals of the electrician trade around this time.

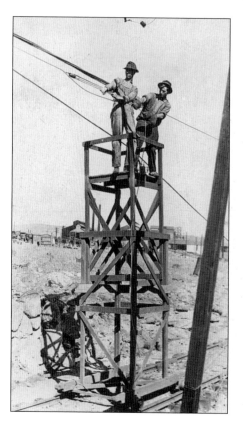

Brother Delmore had landed in Humboldt, Arizona, somehow, and after a while he invited Marshall to visit. When Marshall did go, he found employment as an electrician at the Humboldt Mine. At the left here, with a gasoline blowtorch between his feet, he pulls on a block and tackle as he and his unidentified workmate rig up a "550-D.C. Trolley Line at the Humboldt Smelter." Note that their work tower is on railroad tracks.

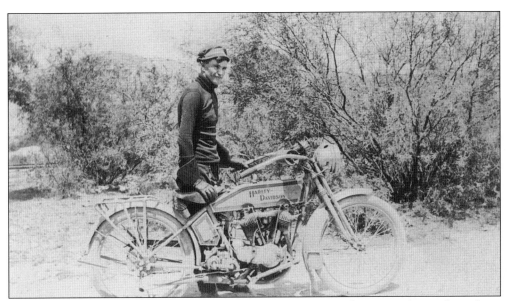

Marshall is seen here with a *c.* 1915 Harley-Davidson motorcycle. Even 85 years later, I am pleased that, way out in pioneer-like Arizona, Marshall had the good sense to ride Milwaukee Iron. His brother was also a motorcycle rider, and in his postcard message asking Marshall to visit Humboldt, Delmore had asked Marshall to "Bring springs also." Parts were tough to find in the Arizona desert, I guess.

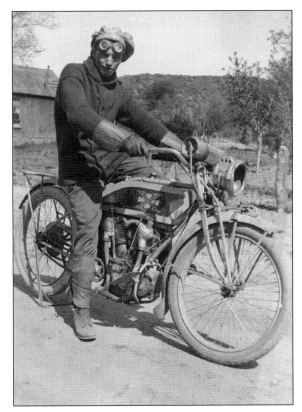

Marshall, with goggles now, is astride a competitor's product. This is an Excelsior Auto-cycle, *c.* 1913. Excelsiors had been made in Chicago since 1907, and the firm was controlled by Ignaz Schwinn, the bicycle maker. The 1913 cycle had a V-twin engine, all-chain drive (they were mostly belt-driven before), and a gray paint finish with red on the sides of the gas tank.

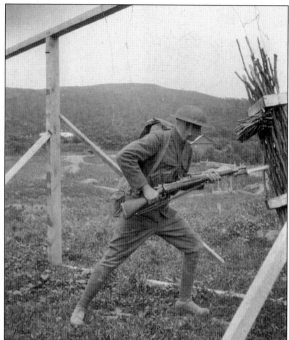

Cain is practicing "Bayonet Drill" during World War I. According to his nephew, Mr. Miles Etzel, Cain spent most of his army hitch with the Headquarters Co. of the 31st Infantry, stationed in Vladivostok, Russia. A major naval port and supply depot during the war, Vladivostok was occupied by a protective multi-national military force from 1918 to 1920. The photographs Cain collected from that period show bits of the soldier's daily life in that city.

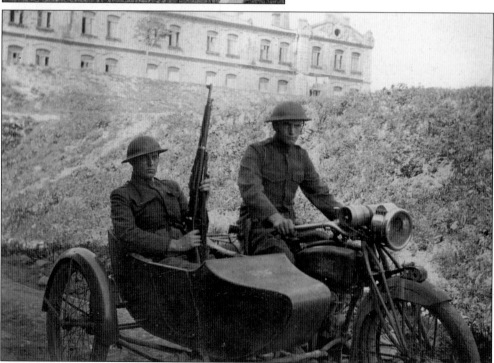

Cain's chief duty was as a motorcycle dispatch rider. His civilian experience apparently allowed him to continue doing what he enjoyed. Here he poses on another Excelsior cycle (painted military olive for the war) with an unidentified, armed doughboy guard in the sidecar. The building in the background was the barracks of the Headquarters Co.'s 31st Infantry in Vladivostok.

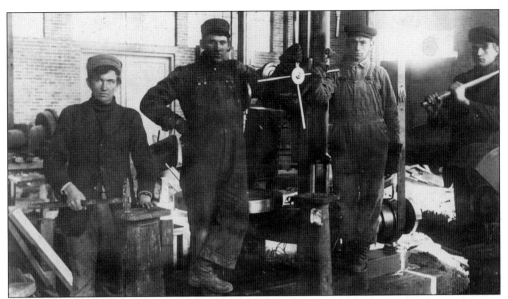

After the war, Cain may have worked in Los Angeles as an electrician wiring early movie theaters. His parents returned to Wisconsin in the 1920s though, this time to northwest Wauwatosa, as did Cain. Across the Menomonee River in Butler, he found work at the Chicago and North Western railroad yard. At right above, he poses in the repair shop with men believed to be (from left to right) Alfred Dornik, Louis Loew, and Bill Drehfabl.

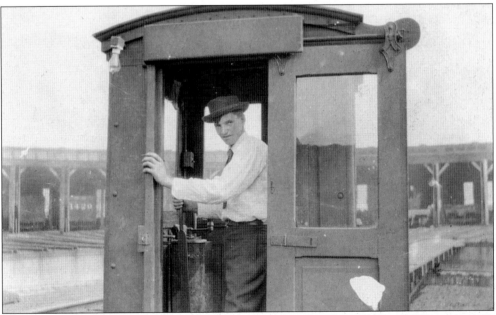

Cain is pictured here in the operating booth of the Chicago and North Western yard's turntable. In those days, steam locomotives, unhitched from their cars, would drive onto this 80-foot-long section of track built on a turntable centered in a circular pit. The turntable operator could revolve the turntable toward any one of 58 train-sized openings in a circular "roundhouse." The turntable lined up with permanent tracks, which led to a stall where a locomotive could be repaired or maintained.

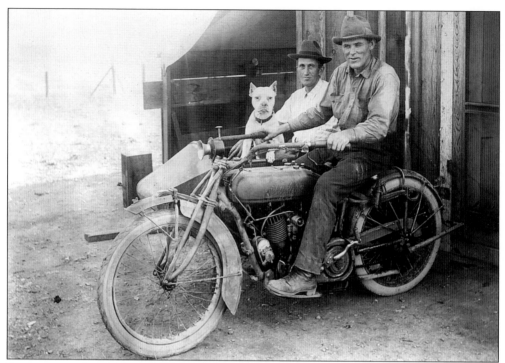

Sometime in the 1930s, we again find Cain on a motorcycle. This time it is an early 1920s Indian cycle with a sidecar. The passengers are his father, George, and an unidentified friend. Indian motorcycles were manufactured in Springfield, Massachusetts, from 1901 through 1953. They were one of the top three in both speed and popularity in the early years, and they are still highly regarded today.

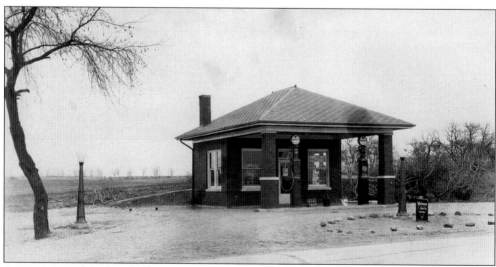

Around 1931, on a corner of his father's farmland, Wadhams Oil Co. built Marshall a lonely gasoline station on the southeast corner of Hampton Road and Lovers Lane Road (Highway 100). Despite the Depression, Cain added services, a drive-up ice cream stand, and took his wife, Erma, to the 1939 Exposition in San Francisco. The station became a Phillips 66, and Cain remained there until his 1964 retirement.

# Six

# CITY PLACES

The sign in this photograph is "West Park, Gallery at the Gate." When the Common Council created the first city parks in 1889, West Park was one of the original eight. This picture is a tintype photograph. Tintypes were popular in the 1860s, and later at tourist spots. Tintypes were developed directly onto a thin iron sheet—*i.e.* no negative. So the photographer had to paint the sign backwards for it to read correctly in the photograph, but he missed the backwards "S." (Photograph *c.* 1895.)

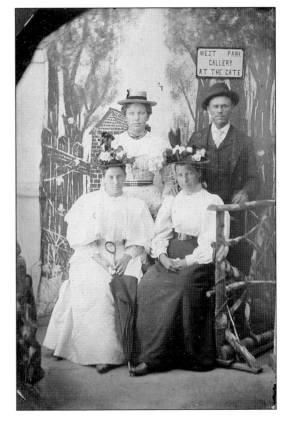

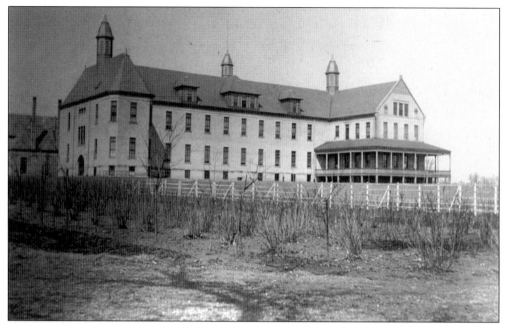

The first building used by Milwaukee County for the county's poor, mentally ill, and sick residents was a Wauwatosa farmhouse purchased in 1852. For $6,000, the County bought the Hendrick Gregg farm, which included a farmhouse, three barns, and 160 acres of land. It soon became known as the Poor Farm. The building above (near Watertown Plank Road), sometimes called the "Alms House," housed and fed the needy. (Photograph April 1904.)

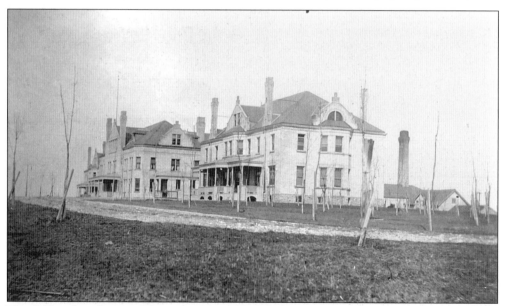

This Milwaukee County "Home for Dependent Children" opened on the County Institution grounds on Watertown Plank Road in 1898. According to the 1985 Milwaukee County Government Report, "Nine buildings housed and educated 700 youths. Older children were indentured and their earnings held until maturity. One young man was paid $2,300, an amount equal to $13,500 today" [in 1985]. (Photograph April 1904.)

The original Hendrick Gregg home housed 25 people that first winter. Another residence was built the next year for the insane. As the years passed, more land was purchased, a county hospital was erected on the County Institution grounds, and in 1889 the "Asylum for the Chronic Insane" was established. This building was one of the seven Chronic Insane structures in use when this photograph was taken in April of 1904.

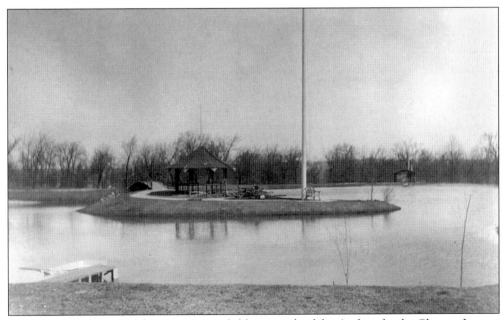

This lagoon was a part of the extensive park-like grounds of the Asylum for the Chronic Insane, and its related Hospital for the Acute Insane. According to the 1985 Milwaukee County Government Report, the grounds included 25 acres of woods, this lagoon, and two lakes. Staff and visitors swam and boated in the lagoon, and summer concerts were presented in the gazebo. (Photograph April 1904.)

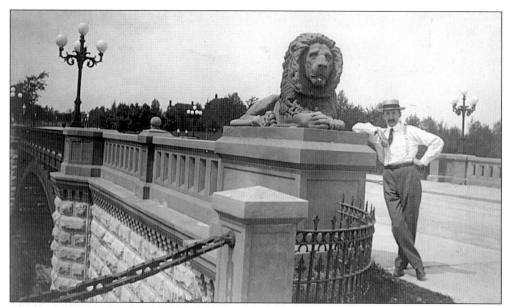

There were eight carved, stone lions guarding two cast-iron bridges in the southern area of Lake Park. These life-sized beauties were sculpted by Paul J. Kupper (not this gentleman, I think), who lived in Milwaukee from 1896 until 1903 (he died in 1908). Lake Park was another of the original eight parks created in 1889. (Photograph *c.* 1915.)

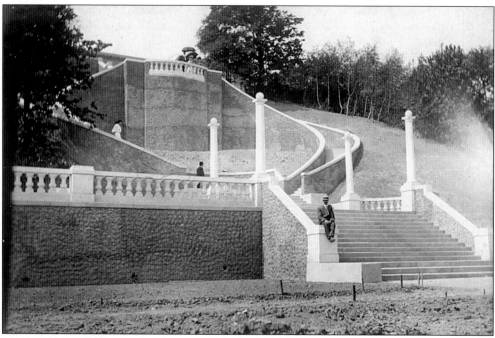

This sweeping staircase leads down to the lakefront from the Lake Park pavilion (built in 1903). The stairway was built by Austin Construction Co., and it appears to be brand new here, with no vegetation near, and wooden stakes in the lower ground plotting the path of an intended sidewalk. Notice the horizontal white concrete railing on the wall at left. Originally there was a paved walkway running south from the base of the curved stair.

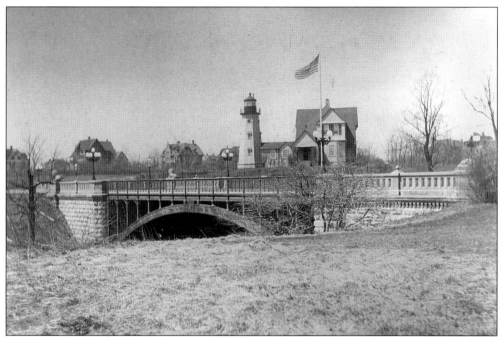

The North Point lighthouse in Lake Park was built in 1855, replacing an 1838 circular stone tower lighthouse that had been on a bluff near where Wisconsin Avenue now runs. The North Point lighthouse seen here was 37 feet high. In 1912 it was rebuilt, making it about 75 feet tall. Being atop an 80-foot-high bluff, the light could be seen over 21 miles away on the lake. (Photograph 1904.)

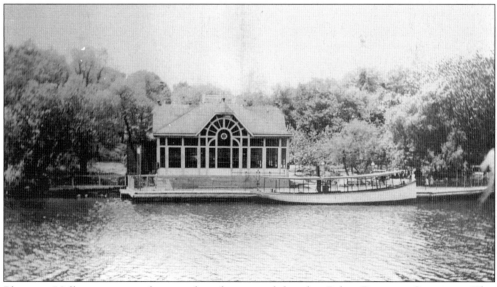

Pleasant Valley was a park owned and operated by the Pabst Brewing Company. This photograph shows their dock on the Milwaukee River, where paying visitors would arrive from downtown. The park was 7.75 acres of well-kept land on the river, bounded by East Concordia, North Humboldt, and East Auer Streets. It operated roughly from the turn of the century to 1952. (Photograph 1903.)

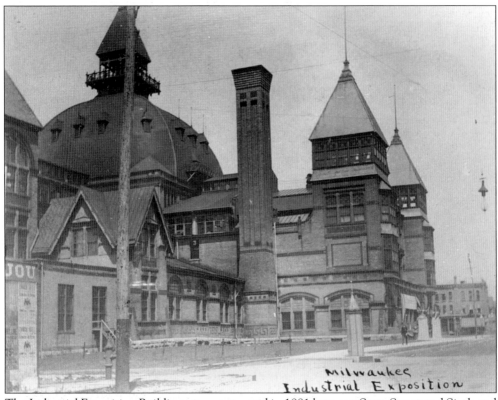

Milwaukee
Industrial Exposition

The Industrial Exposition Building was constructed in 1881 between State Street and Sixth and Kilbourn Streets. Edward T. Mix designed this delightful brick and glass mishmash to showcase our best industrial and cultural products. Local businesses rented space each fall, often creating their products in their displays. Milwaukeeans proudly attended art shows, concerts, and conventions here. A fire leveled the building in 1905, which led to the 1909 opening of our current Auditorium. (Photograph c. 1903.)

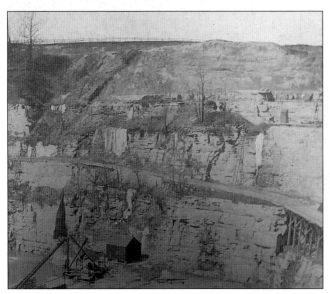

The Story Bros. Quarry, owned by Albert and William Story, after their father Hiram, was in the town of Wauwatosa in this 1904 photograph. Wauwatosa's eastern limit at that time was North Thirty-fifth Street. The limestone quarry, nearly 90 feet deep, was just west of Forty-fourth Street, south of Bluemound, and just north of the westbound lane of today's I-94—in other words, about where Milwaukee County Stadium's northern parking lot is. Story Parkway runs along the ridge near what was the quarry's deep wall.

Hey, forget those boxy old sand castles, this kid had imagination and drive. This was McKinley Beach and its beach house. People could rent swimming suits there, paying a small deposit for each suit. Night swimming was also allowed. In June 1933, the Common Council even okayed spending $1,000 for flood lights for permitted night swimming in July and August. (Photograph c. 1920.)

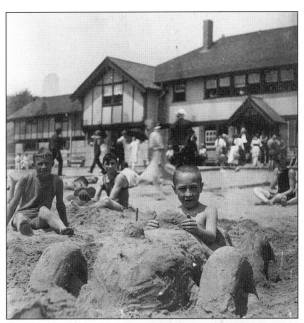

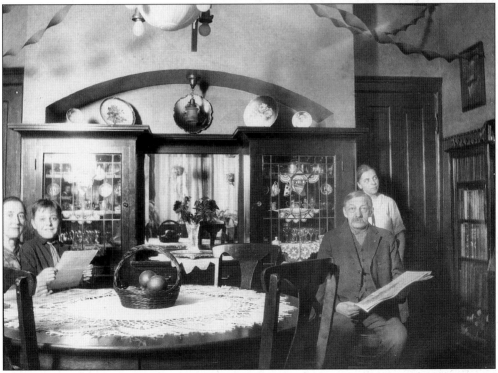

This picture better represents a place in the heart than a place in the city. This typical Milwaukee bungalow dining room has sturdy, medium-brown woodwork and furniture. A lighted, recessed, curved ceiling highlighted the built-in china cabinet with stained-glass doors and leaded mirror. The swinging door led to the kitchen, and the left door led to a walk-in pantry. Adolph and Charles Strassburg, both broom makers, lived at this Fifth and Lloyd address, c. 1920.

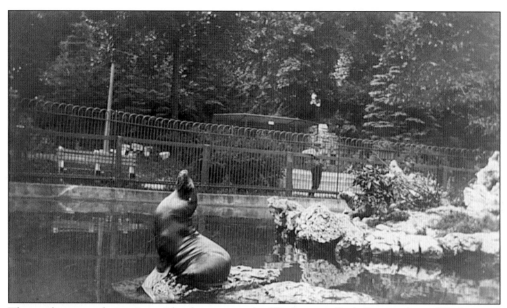

The sea lions, on their private island, were popular Washington Park Zoo residents. Washington Park, originally named West Park, acquired its first sea lions in 1907. In this 1922 photograph, one sea lion is enjoying the sun, and another is partially visible behind the bush. Three sea lions, two male and one female, resided at the zoo in 1922. Unfortunately, animal husbandry knowledge was limited in those days, and all died of various causes by the end of 1923.

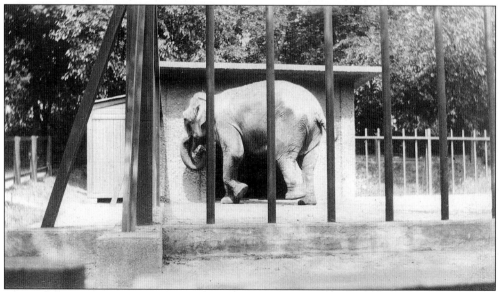

The first elephant purchased by the Washington Park Zoo was Countess Heine, above. She was about four years old when the zoo acquired her in 1907, using money raised by Milwaukee citizens. When purchased, this Indian elephant weighed 1,585 pounds, and when she was sold in 1923 she weighed about 5,000 pounds. She was replaced in 1923 by a three-year-old African elephant that stayed until 1953. (Photograph August 1922.)

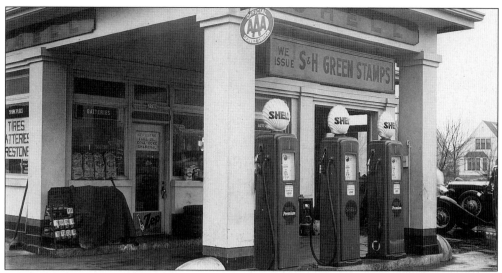

This is pretty modern looking for a 1927 gasoline station. They offered gas at 22.7¢ per gallon, as well as basic auto supplies, kerosene, coal coke, charcoal, and S & H Green Stamps with purchases. Signs advertise that they were recognized by the Milwaukee Motor Club and AAA. (Photograph July 5, 1927, by James Murdoch.)

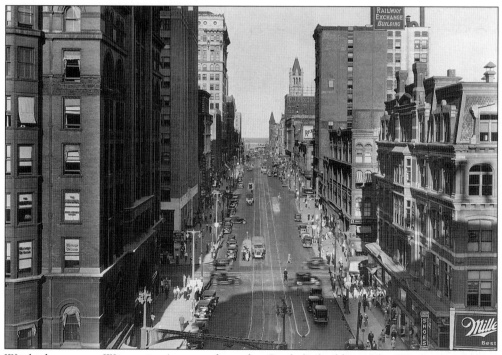

We look east, up Wisconsin Avenue, from the Gimbel's building. The Wisconsin Avenue bridge crosses the river at the lower left. At right is the Mack Building, where the Marine Bank's plaza is now, and the Pabst Building is at left. The first intersection is North Water Street, and just past the Mack Building is the Iron Block, which was constructed of cast-iron sections shipped here by boat in the 1860s. The post office is the tallest pointed tower in the center background. (Photograph August 1932, by James Murdoch.)

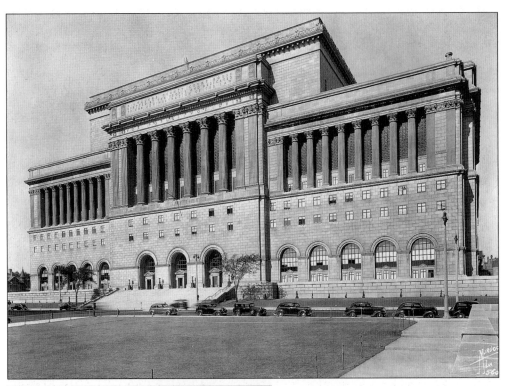

The building's inscription reads, "Milwaukee County Court House Erected By The People And Dedicated To The Administration Of The Law." Facing North Ninth Street, the design (for our third courthouse) was the result of a nation-wide architectural design contest. Of the 33 entries, Albert Ross of New York won, and the building was completed in 1931. Frank Lloyd Wright called it a "million dollar rockpile." (Photograph August 1938, by James Murdoch.)

The city fathers wanted our downtown public buildings to be a proud "Civic Center," with City Hall at the east and the courthouse at the western end. Walk around behind the bright new courthouse though, and one would have looked down upon this poor city neighborhood. Where this black family trods over a narrow cobblestone street, 30 years later interstate highway I-94 would be built. (Photograph *c.* 1933 courtesy of the Wisconsin Black Historical Society/Museum.)

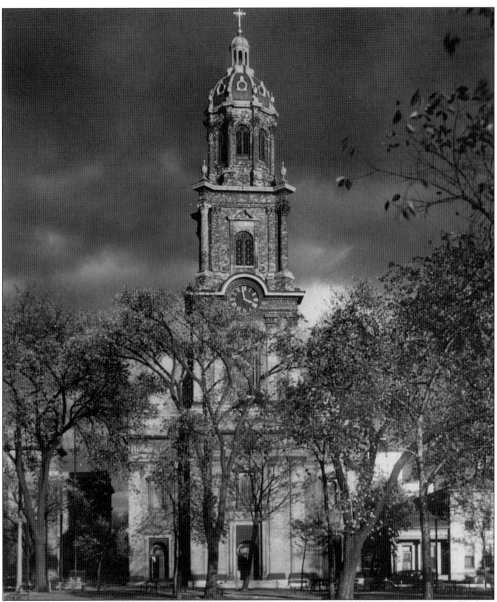

St. John Cathedral, on North Jackson Street, was completed in 1852. Catholic Bishop John Martin Henni purchased the land in 1844 and traveled to Europe in 1848 to raise the nearly $30,000 needed for construction. By the late 1870s, the tower was considered unsafe, so the portion above the clock was removed in 1880. A new, much taller tower was built in 1893 and was generally regarded as being quite beautiful. On January 28, 1935, a devastating fire destroyed the church and its contents, including half a dozen 6-foot-high, gilded candlesticks from France, stained-glass windows designed in London, an oil painting from Munich, and a wonderful pipe organ. The fire and intense heat weakened exterior walls and collapsed the roof into the gutted interior. The tower alone remained intact. A major rebuilding project began in 1936 and was finished in 1942. Normal services resumed with the midnight mass on Christmas Eve in 1942. (Photograph 1936, by Jim Conklin.) (It was this picture, the first I ever bought, which began my two-decade-long hobby of collecting old photographs.)

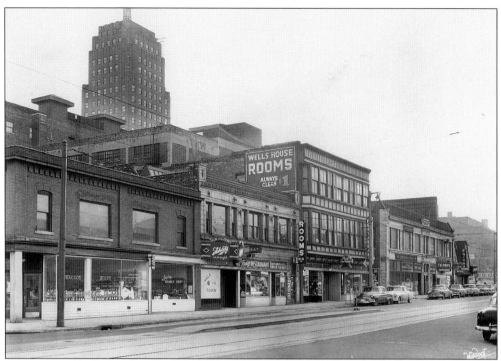

Here is the "South Side of West Wells Str., Bet[ween] 5th & 6th Str." From left to right are the following: a liquor store, "Legion Barber Shop," "Talk O' The Town" (Schlitz), "Tasty Food Shop," "Harry Kahn's Place" (resale shop), "Wells House Rooms" ($1), a used clothing store, "White Castle" bar (Pabst), a restaurant, "Spheeris Bros. General Merchandise," "Congress Billiards" & sporting goods, "Terri's Floor Shows" (Braumeister Beer), "$ Money To Loan $," and "Chicks" (Schlitz). (Photograph February 1955, by James Murdoch.)

The "Third Church of Christ Scientist," on the northwest corner of Sherman Boulevard and West Locust Street, was built in 1922. Members of the Christian Science Church believe in adherence to the Bible, and they follow their denominational textbook, *Science and Health with Key to the Scriptures*, written by Mary Baker Eddy in 1875.

# Seven

# KINDERGARTEN TO COLLEGE

Written on this photograph is the following: "St. Marys Institute and Mother House of the School Sisters of Notre Dame, Milwaukee St. cor[ner] Ogden." These first seven photographs show St. Mary's Institute and the Notre Dame Convent. This fortress-like building (the west wing of four sides) housed the institute. Opened in 1851 in a smaller building, it was a school for upper-class young ladies of all faiths. In the 1840s, Bishop John Henni journeyed to Bavaria to get help from King Louis I in gaining favor with the order of the School Sisters of Notre Dame in Bavaria. (Photograph c. 1880 by William H. Sherman.)

Not only did the School Sisters approve, but King Louis provided money to buy land and erect a building in Milwaukee. This became the principal motherhouse in America for the School Sisters of Notre Dame. By the late 1860s, construction had filled the city block bounded by Milwaukee, Ogden, Jefferson, and Knapp Streets. This stairway leads from the basement to the garden level and the rear of a vine-clad grotto. (Photograph c. 1880, by W.H. Sherman.)

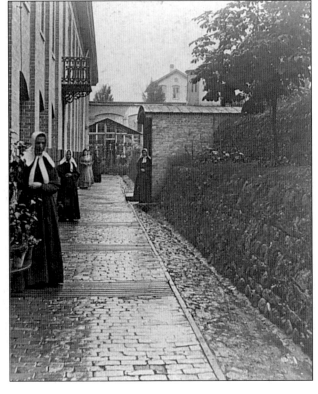

The convent, a mostly four-story rectangular structure, surrounded a large inner courtyard. The courtyard contained many trees and a large fountain, with half the yard paved with bricks and stone. This city block was hilly, requiring stone retaining walls and much leveling during construction. This scene is the walled-in lower arcade, which ends at the glass front of their greenhouse. (Photograph c. 1880, by W.H. Sherman.)

The School Sisters of Notre Dame's purpose was to train young women to be teaching nuns. Between 1886 and 1892, the institute, day school, and high school were each closed to make room for novices and candidates. Evening and weekend classes for day students remained, however, until 1958. By 1957, the order had 6,500 teaching nuns in schools nation wide. This building is the grotto, whose dim interior replicated the original at Lourdes. (Photograph *c.* 1880, by W.H. Sherman.)

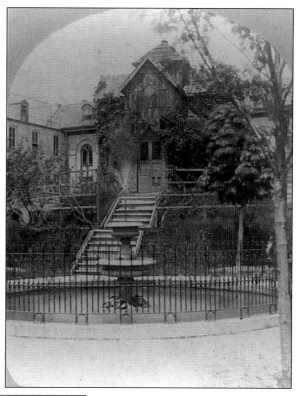

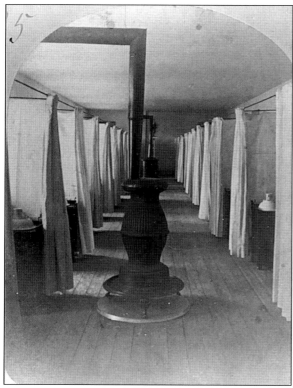

This is the "Young Ladies Boarders' Dormitory, St. Marys Institute." The two wood-burning heating stoves in the room were later replaced by radiators. Each girl had her own curtained sleeping space. Each cubicle had a small stand with a top drawer and two shelves; a wash basin, water pitcher, and cup; one wooden chair; and one twin-size, single bed. In the early years of the institute, most students were boarders, due to the "wilderness dangers" around. (Photograph *c.* 1880, by W.H. Sherman.)

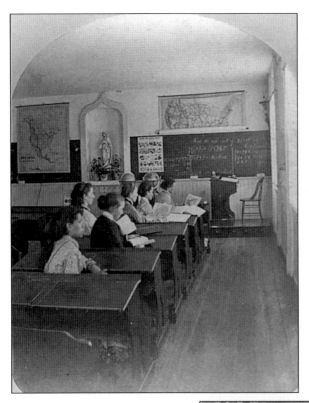

This photograph is labeled "Schoolroom at St. Marys Institute, Milwaukee, Wisc." Besides maps of North America and a partially unrolled United States, there are two world globes and a chart showing many plants' leaves and flowers. On the blackboard is this problem: "Find the cube root of 413493625" and, below that, a mathematical solution. I see no light sources except windows. (Photograph c. 1880, by W.H. Sherman.)

This appears to be a two-story-high study hall. There are two coal oil lamps with round reflectors on the far wall, and similar lamps between the windows. Other rooms had large, glass-chimneyed chandeliers. Strict rules governed candle and lantern use in order to prevent fires. Today, the Sisters of Notre Dame are based in Elm Grove. The old "Convent on the Hill" was replaced with low-income housing for the elderly in the 1960s. (Photograph c. 1880, by W.H. Sherman.)

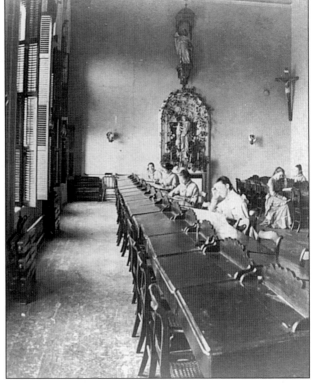

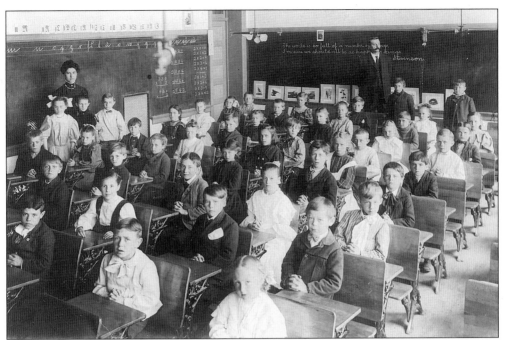

This is a second grade class picture, with 46 pupils (which may be two classes), probably at the Twenty-first Street elementary school. The teachers are Miss Mills and Mr. Hardtke. All seated children have their hands neatly folded but one. Note the bare gas jets for lighting. The blackboard features a Robert Louis Stevenson quote, "The world is so full of a number of things, I'm sure we should all be as happy as kings." (Photograph 1908 .)

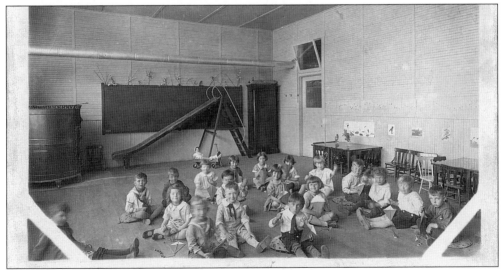

"Picture taken at Nee-Ska-Ra School 1924. Myrth & Marion Fidler 4 years old Kindergarden on 55 and galena St. we are in the last Row" (information as written on the back of the photograph). The school was first listed in a city directory in 1925. Rumor has it that when the school opened around 1920, there was a small spring on the grounds named after an American Indian. The school was given that name, and it still serves young children today, under the name Neeskara School. (Photograph 1924.)

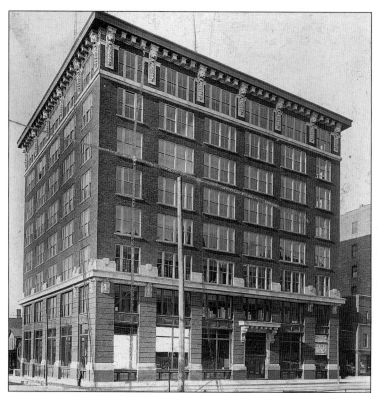

The Continuation School was the result of an experimental 1911 Wisconsin law that allowed 14- and 15-year-old school dropouts, who were working full time, to go to school five daytime hours per week. Employers were required to let these workers attend weekly. Older students could participate in the evenings. The school, housed originally in the Manufacturers Home Building at left (on Mason Street near the river), opened in 1912, and attendance grew rapidly. (Photograph 1916.)

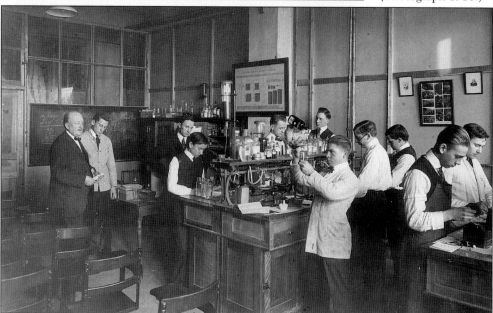

Teacher Robert L. Cooley (left), overseeing this class for druggist clerks, was the professional teacher hired to open and operate the school. With an annual budget of $3,500, he had 2,200 boys and girls attending part-time specialized high school classes by the end of 1912. This educational innovation, the first of its kind nationally, spread quickly through other large Wisconsin cities. (1916 photograph.)

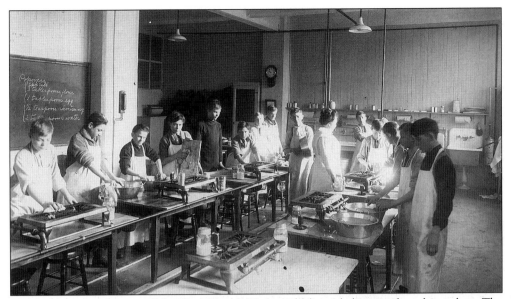

This is the Continuation School's 14- and 15-year-old boys' baking and cooking class. The blackboard presents a recipe for "Popovers," but we must have just missed them. The woman instructor has the boys cleaning bowls, boards, and burners. In 1916, the school's name changed to the Milwaukee Vocational School, and planning began for construction of their own, six-story building at Seventh and State Streets. (Photograph 1916.)

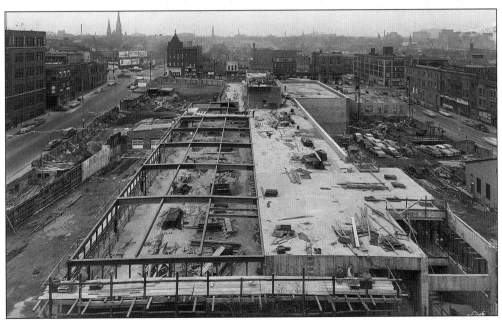

By 1923, the highly rated Milwaukee Vocational School completed its new building. Yes, the experimental Continuation School had grown to become the Milwaukee Area Technical College. Educational and building expansions continued. This view overlooks early construction of the shop and technical building at Sixth and Highland. The I-45 freeway extension later replaced the buildings at the far end of this city block. (Photograph 1953, by James Murdoch.)

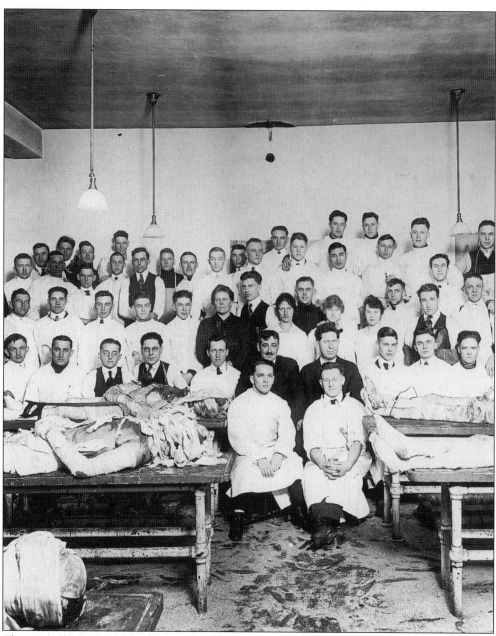

This partially cropped, unofficial class picture was taken in the anatomical dissection room of Marquette University's Dental School, then located at Ninth and Wells Streets. All dental students were required to study and dissect a human cadaver for at least one school year. Dentists must, of course, completely understand the connections and relationships between all upper body nerves, blood vessels, bone structures, and muscles in order to safely care for their patients. The March 19, 1920 issue of the *Marquette Tribune* stated that bodies "come from asylums and public morgues, and are acquired pursuant to special statute." When received in the school's unheated basement morgue, the bodies were injected with a mix of formaldehyde, arsenic, and carbolic acid, and then "are wrapped in Egyptian gauze, are numbered and placed on shelves," until needed for a class. (Photograph 1918, by Francis E. Jones.)

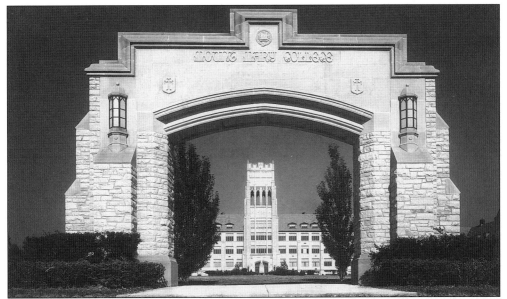

Mount Mary College's Notre Dame Hall is seen here through the Memorial Arch. This Catholic college for women was begun as St. Mary's Institute in Prairie du Chien in 1872, by the School Sisters of Notre Dame. In 1913, they were accredited as Wisconsin's first liberal arts college for women. Moving to Milwaukee in 1929, they chose an 80-acre hill with few trees or neighbors. From that earthen mound came the name Mount Mary College. (Photograph July 1934, by James Murdoch.)

This main library reading room is in Notre Dame Hall, the primary building on campus. When a new library was built in 1981, this room was rededicated the Walter and Olive Stiemke Memorial Hall and Conference Center. It is currently used for music recitals, faculty conferences, and other meetings, and it houses the exhibits of the Mount Mary historic costume collection. (Photograph February 1935, by James Murdoch.)

Two students relax in a lounge called the Wicker Room. They were Vivian Kasta and Mary Jane Berdoll. (Photograph June 1934, by James Murdoch.)

This lounge on the first floor of Caroline Hall (a residence for students) had many names over the years, based on the furniture scheme—Beige Room, Plaid Room, etc. In the early 1980s, this room was renamed as part of the Ewens Center, a special program for women over 24 who attend special courses, seminars, and other events that may encourage re-entry into a regular degree program. (Photograph July 1934, by James Murdoch.)

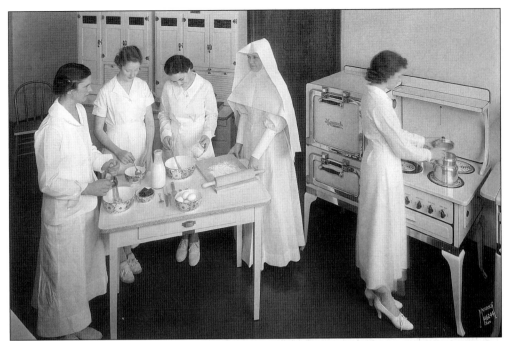

This was a functional activity of the Home Economics Department. On the third floor of Notre Dame Hall was a complete apartment with kitchen, bath, dining, living, and bedrooms. Students lived there for specified times to learn proper methods for running a household. Sister Mary Albert supervised the students. Today the area is used for Restaurant/Hotel Management and Consumer Sciences training. (Photograph September 1934, by James Murdoch.)

Yes, Virginia, this is the cafeteria. The menu board shows these prices: Veg. Soup–5; Fruit Salad or a Tomato–10; Veal Loaf with Lettuce Salad–10; Ham–10; Plum–3; Donut–2; and Cocoa, Milk, Tea, or Coffee–10. At the time of this writing, this cafeteria still looks just the same, except for having more modern furnishings. (Photograph September 1934, by James Murdoch.)

Not only was swimming popular in the 1930s, but intramural teams competed quite seriously. Students could earn trophies, emblems, and class numerals. The pool's dimensions were standard for that time: 20 by 60 feet, 3 to 9 feet deep, with a volume of 57,000 gallons. Today this swimming pool is used mostly for water aerobics. (Photograph June 1934, by James Murdoch.)

The first Milwaukee president of Mount Mary College, from 1929 to 1954, was Edward A. Fitzpatrick, Ph.D. Since Dr. Fitzpatrick retired, Mount Mary has been led by six presidents—all of them women. Today the college offers many professional and pre-professional programs. Their 1998 enrollment totaled 1,322 students, half being of traditional age and half over 25. (Photograph July 1934, by James Murdoch.)

# *Eight*
# POLITICIANS AND OTHER NOTABLES

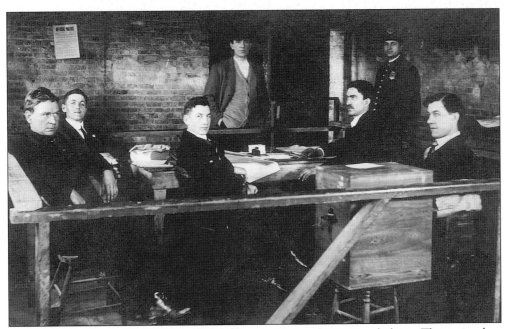

"In voting booth 1912—Auer Ave. School" is written on this postcard photo. The voting box is behind the railing. In January 1912, the *Milwaukee Sentinel* wrote that school buildings should be used "for election purposes on payment of a rental of $5 a day." I believe the seated man with a mustache is City Attorney (later Mayor) Daniel Hoan, and the man second from the left may be Hoan's special assistant, Clifton Williams.

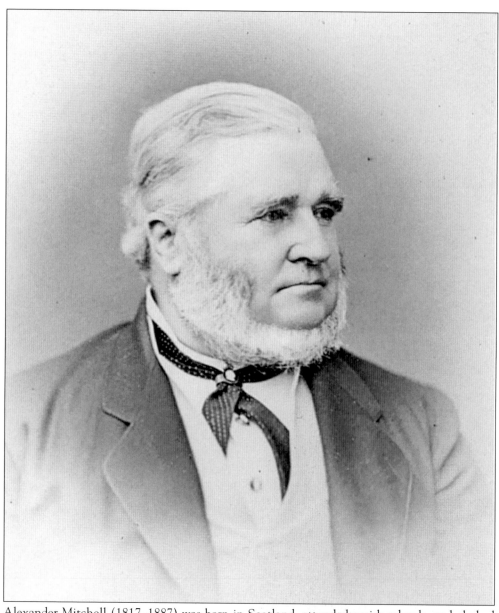

Alexander Mitchell (1817–1887) was born in Scotland, attended parish schools, and clerked for a few years in a legal firm and a bank. A family friend in Chicago asked Alex to run his new firm in Milwaukee. Young Alex agreed, and in 1839 he arrived here with $50,000 cash to set up the Wisconsin Marine and Fire Insurance Company, which provided quasi-banking services, and which much later became the Marine Bank. He married Martha Reed in 1841, and they had their only child, John (a future United States senator), in 1842. In 1848 Mitchell built a reasonable brick house on Wisconsin Avenue, which he expanded for decades—it is now the Wisconsin Club. In the panicky economic times of 1857–1865, he was instrumental in keeping the city from going bankrupt. He also combined several small, failing railroads, making himself president of both the Milwaukee Road and the North Western Road. His 1870 personal financial worth was $20,000,000. When he began the first of two terms as a United States congressman in 1871, he was the wealthiest congressman in the nation. (Photograph 1883.)

Matthew Hale Carpenter (1824–1881) came to Milwaukee in 1858. This flamboyant lawyer switched parties around 1863, becoming Republican. He was elected a United States senator in 1869 and 1879. Carpenter was a noted orator, constitutional expert, and part owner of the *Milwaukee Sentinel*. Historian E.B. Thompson wrote, "[Carpenter] never aspired to statesmanship; he was content to be a good lawyer in politics." (Photograph c. 1878 by Harry Sutter.)

Late in his career, Henry J. Baumgaertner (1846–1901) wrote the poem cast on the 11-ton bell in City Hall's bell tower: "When I sound the hour of the day / From this grand and lofty steeple, / Deem it a reminder, pray / To be honest with the people." Trained as a sign painter, Baumgaertner was elected 13 times to the Common Council and served as president during four terms. (Photograph c. 1872 by August Schneider.)

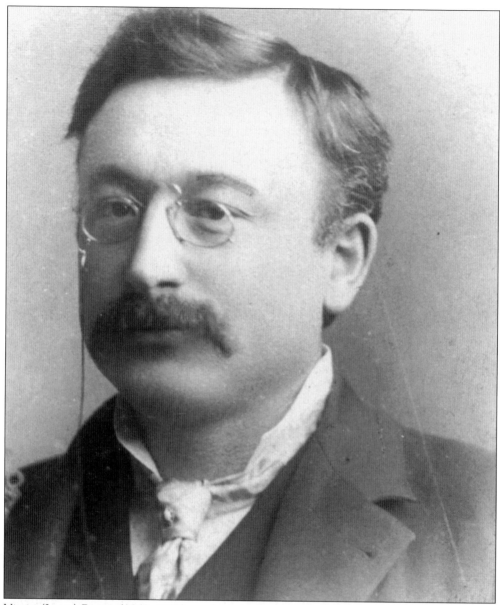

Victor (Louis) Berger (1860–1929) was born in Austria, arrived in the United States in 1878, learned English in New York, and moved to Milwaukee around 1881, where he taught German. Over the next 30 years he became the editor of three newspapers, including the *Milwaukee Leader* (1911–1929). Berger was elected in 1910 as "Alderman At Large" here, to serve through 1914, but he resigned in 1910. His true political fame was due to the fact that he became America's first Socialist United States congressman. Milwaukee's Fifth District elected him six times to Congress, but the House of Representatives twice denied him his seat due to his pacifist writings during World War I. As a Socialist, he struggled for old-age pensions, workers' unemployment compensation, honest government, civil liberties, public housing, and public ownership of Milwaukee's trolley system. All eventually became law. His death was the result of an urban accident—he was run down by a trolley car. (Photograph *c.* 1897 by Henry Klein, courtesy of the Milwaukee County Historical Society.)

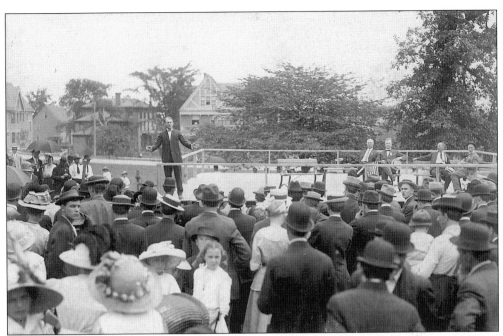

John C(asimir) Kleczka (1885–1959) attended St. Stanislaus parochial school. He graduated from Marquette College in 1905 with a B.A. degree, later earning Masters and Law degrees. He was promptly elected to the State Senate in 1908 as a Republican. This *c.* 1912 photograph shows him speaking in a park at some public event. After one term in the State Senate, he decided not to seek re-election, and in 1914 was appointed locally as a court commissioner.

In 1918, John Kleczka was elected to the United States Congress. This 1920 signed postcard portrait of him was an official campaign advertising piece for his Congressional re-election run: "RE-ELECT John C. Kleczka Representative In Congress Fourth District—Republican Column ELECTION TUESDAY, NOVEMBER 2nd." He won re-election but did not return to Congress after two terms. He practiced as a lawyer until about 1923, when Governor Kohler appointed him a circuit court judge, in which capacity he served honorably for many years.

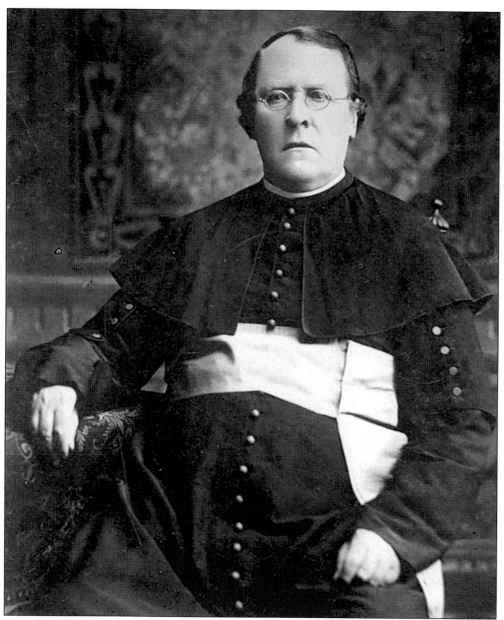

Right Reverend Monsignor Leonard Batz (1826–1901) was the founder and first pastor of SS. Peter and Paul Church. Arriving from Bavaria in the 1850s, he was soon ordained by Bishop John Henni. Reverend Batz was pastor of St. Mary's Church (on Broadway) from 1860 to 1880, except for a seven-and-one-half-month period while he served at St. Peter's Chapel. After 1880, he returned to St. Peter's for nine years. In July of 1882 he was installed as Monsignor Batz. In 1889, he had the St. Peter's building removed from its original foundation to a new site on Milwaukee's east side, thereby founding the beginning of the SS. Peter and Paul Church we know today. The church school, operated by the School Sisters of Notre Dame, began regular classes in September 1889. Construction of a new church began, the cornerstone being laid on June 1, 1890. The building was completely paid for within two years and was consecrated on April 24, 1892. (Photograph c. 1897, by Charles Brodesser.)

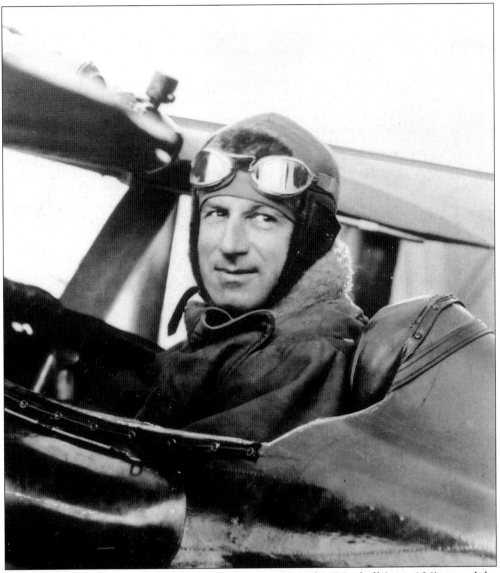

General William "Billy" Mitchell (1879–1936), grandson of A. Mitchell (page 106), joined the Army at age 19 as a private. A hard-working, inventive personality, he served in Cuba, the Philippines, and Alaska. In 1908 he became acquainted with the Wright brothers. In 1916, as a lieutenant posted in Washington, D.C., he paid for his own private weekend flying lessons because the Army didn't yet train pilots. In WW I he was America's military expert on European air forces, and by late 1918 he was a brigadier general commanding 90 squadrons of airplanes in Europe. His unceasing insistence that airplanes should be first-line offensive weapons in an independent air service developed into public flare-ups against superiors who wouldn't see things his way, which then led to his court-martial and demotion. It wasn't until WW II that the world fully realized the truth and value of Mitchell's air power assertions. The new B-25 airplane was named the Mitchell bomber early in the war. After the war, Mitchell was posthumously awarded a special Congressional Medal of Honor. He poses here in a Thomas-Morse military pursuit plane. (Photograph *c*. 1921 Army Air Service, courtesy of George A. Hardie Jr.)

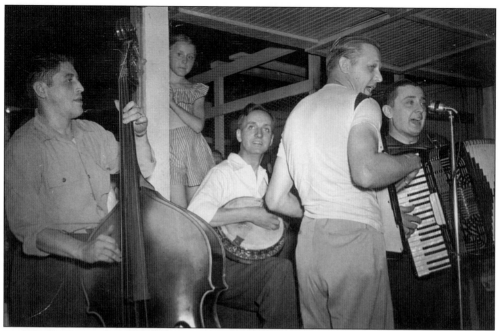

Frankie Yankovic (1915–1998) was not truly a Milwaukeean, but he was darn close. This Cleveland accordionist signed with Columbia Records in 1946. In a 1948 Milwaukee polka contest, he was crowned "America's polka king." Within two years he was playing in Hollywood, and he always looked back. Frankie and Milwaukee loved each other. Playing here around 1949 are, left to right, Ad Church, George Kuk, Johnny Pecon, and Frankie Yankovic.

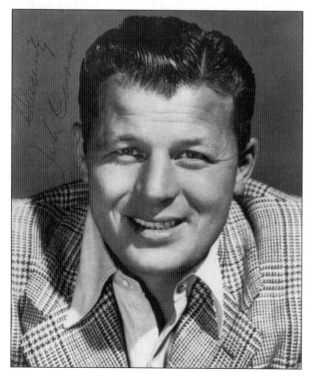

Jack Carson (1910–1963) was born John Elmer Carson in Canada. The family moved to Milwaukee's east side around 1913. He acted in college plays just for the fun of it, but returned home after college to sell insurance. With income scarce in the early 1930s, he tried vaudeville for five years before trying Hollywood. He was a very good supporting actor in many famous films, but he always called Milwaukee home and often proudly promoted Milwaukee in Hollywood. (Photograph 1946.)

# Nine
# FOLKS AND FAMILY

These unidentified Scotsmen are wearing
traditional Scottish Highland outfits, with
kilts and tartan plaids. Each Scottish clan
wore a plaid pattern of their own style and
color scheme. The 1850s saw a large
migration of Highlanders to Milwaukee, due
both to political changes and to widespread
crop failures in Scotland's mountainous
areas during the same time as the infamous
Irish potato famine. (Photograph c. 1880 by
Frederick W. Streit.)

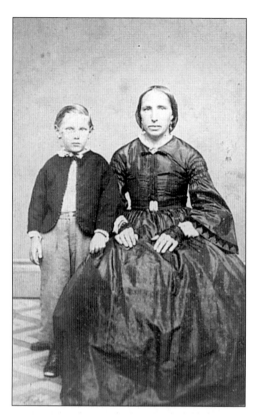

This *c.* 1867 young woman's appearance is fairly typical of styles popular two or three years earlier, during the Civil War. Her hair was confined and kept away from the face. The dress is one fabric, all black, with a fitted bodice and very simple trim. White undersleeves end in lace cuffs, and the straight belt is narrow (popular with younger women), joining below a broach (very common jewelry). (Photograph by Leonz Meyer.)

Although white wedding dresses were in use before the Civil War, black dresses were much more common. As in this *c.* 1880 photograph, most wedding dresses were black and were simply the woman's best dress of her best fabric, perhaps with special trimmings added, rather than a specially purchased dress. And it was fairly unusual that the woman is seated for the picture rather than the man. (Photograph by Simon L. Stein.)

This page features doll carriages and dolls from two different generations. You will note differences in the dolls' and the girls' clothing styles. In regard to the buggies, though, the wooden handles are nearly identical. The top carriage has abundant fringe, while the lower one has none. The wheels are similar to the then-current bicycle styles—this buggy has two wheel sizes, with no padding (just wooden rims). (Photograph *c.* 1879 by Frederick Streit.)

This lower style features hard rubber tires, and all four wheels appear to be the same size. This buggy also sports a hand-sewn blanket. The girl in this photograph is Sue. Later, in 1928, she became a true believer in maintaining a healthy life by always eating a healthful diet. She practiced what she preached and outlived three husbands. As of this writing, Sue Hayssen is 97 years old and still lives in her own home in a Milwaukee suburb. (Photograph *c.* 1908.)

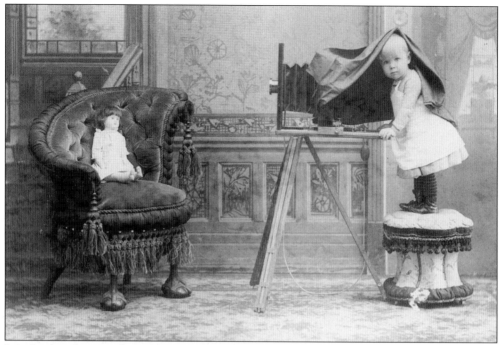

I credit this photographer's creativity for producing an unusual, attractive, and fun picture of a child and her doll. Unfortunately, the child is unidentified. William A. Armstrong was the photographer, and his studio was on North Broadway from about 1879 to 1896. The camera and tripod were real studio equipment, and the fanciful chair was designed for photographers—one chair could look like two if only half was photographed behind a sitter.

As a collector of old photographs, my eye is always alert for the unusual, be it an activity, a pose, objects pictured or, in this case, a perfectly beautiful spring outfit on a pretty girl. The utter whiteness of this head-to-toe ensemble is unusual for the 1890s. Clothing was most often black, with white accents or white portions. The airy white parasol obviously expands the overall impact of this image. (Photograph c. 1895 by Charles F. Dittmar.)

116

This swan-shaped sleigh/baby buggy is just too wonderful for words. I do not know if such a sleigh was actually available for the average person to purchase. It is possible that it was one of the specialty items professional studio photographers could buy as fancy props for their pictures. All of the "snow" in the air here, and probably all the "snow" on the ground, was a special effect created on the negative after the photograph was taken. (Photograph *c.* 1889 by William Wollensak.)

The Victorian age had a fondness for lace. An over-abundance of frills and lace on young boys was perfectly darling fashion for many years, and I have seen photographs of boys who scowlingly resented being immortalized in such clothing. This young master doesn't seem to be too put off by it all, but then, he does have his rifle and his pet dog to provide a measure of balance. (Photograph *c.* 1896 by Paul Prescher.)

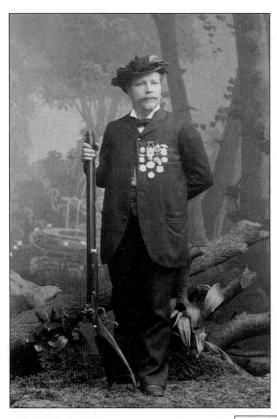

"August Engel, Member of Milwaukee gun club Sharpshooters" was photographed around 1881. Engel's employment situation improved from machinist in 1869 to brass finisher, to foreman at Hoffman, Billings & Co. (a brass foundry) in the 1880s, and finally to vice-president of the Milwaukee Brass Manufacturing Company in 1894, a position he held until 1917. (Photograph c. 1881 by Victor J. Torney.)

It is often said that everyone in the 1800s always looked serious when they had their photograph taken. That is mostly true, because it was such an unusual and sometimes costly event. But here is an exception—cross-dressing men. These young gents have over-dressed, rather than wear everyday clothing, so I suspect they are made up for some fun college play or prank. (Photograph c. 1895 by Louis Hagendorff.)

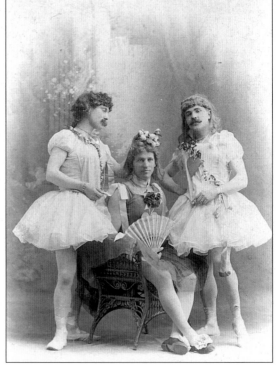

"Yourself and family are cordially invited to attend a supper given in honor of our son's Bar Mitzwo. Sat. June 25, at 8 p.m. at the Labor Lyceum Hall, corner 8th [&] Garfield Ave. Mr. & Mrs. S. Meiroff." So said the message on this *c.* 1920 photo postcard. This type of friendly invitation was more common than many would think in early Milwaukee. There were Jewish settlers and businessmen living here as early as 1836. (Photograph by Rudolph P. Heinrichs.)

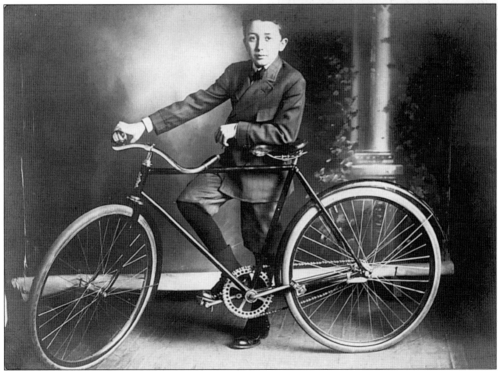

"Best wishes for a Merry Christmas and a Happy New Year. Adler—Julius & Soph." This postcard photo, sent to their in-town friends, the Roth family at "1502 State St., City," was either mailed late, or the happy son of Julius and Soph. received his shiny new bike early. (Photograph *c.* 1916.)

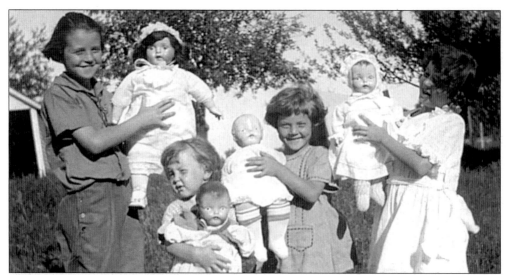

For many summers in the 1920s, the Owen Williams (page 20) family rented Mr. Jenkins's cottage on Lower Nemahbin Lake. Owen's daughters and their cousin proudly display their Bye-Lo Baby dolls. With their later married names after each, they are, from left to right, as follows: (in front) Jane Williams (Klatte); (in back) Ronnie Williams (Chesbrough), with her doll "Ronnie"; Suzanne Williams (Fuerstenau); and Elizabeth Roberts (Peirce). (Photograph 1923 courtesy of Karen Zigman-Fuerstenau.)

In 1921–1922, Mr. and Mrs. Russell and Ida Mills set out from Milwaukee on the adventure of a lifetime. It was years before the first interstate highways, and most roads were rutted dirt or gravel. At a time when what few maps there were directed the motorist from one local landmark or unusual tree to the next, this happy couple bolted their kitchen-in-a-box to their Chevrolet (?) and drove the entire circumference of the United States, clockwise. (Photograph 1922 by Louis F. Kuhli.)

Mr. and Mrs. Eleuterio and Raquel Valdovinos immigrated to Milwaukee from Mexico in 1930. Their children were, from left to right, as follows: Eleuterio, Ramiro, Reynaldo, Rodrigo, Gustavo, and Salvador. The family's oldest, Beatriz, and youngest, Raquel, are not shown. The four oldest kids were born in Mexico, and the four youngest in Milwaukee. Gustavo became the first Hispanic firefighter in Milwaukee, and his son, Mark, became Greendale's first Hispanic policeman. (Photograph c. 1937 courtesy of the Arnoldo Sevilla Collection.)

"Geo. Dooley, Real-Estate Dealer, Just Married. —Will Trade a whole - LOT - for a Baby Buggy." So read the humor on the other side of this gracious carriage provided by some friend (?) on George and Bee's wedding day, August 26, 1924. The styles of the horses and driver match the carriage in quality. Other carriage announcements are "I Chased her Till She Caught Me," and "Geo. Oh How you will work from Now <u>on</u>." (Photograph August 1924.)

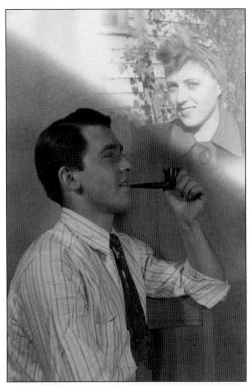

Joe Glocka and Mathilda Schnatl grew up as friends in a very ethnically-mixed Milwaukee neighborhood. In 1942, after dating for five years, Joe was a journalism major at Marquette University. Practicing with his camera and darkroom, he created this romantic "daydreaming" double exposure. He graduated that year, married Mathilda in 1943, landed a copywriter job with the *Milwaukee Sentinel* later that year, and was drafted in 1945. (Photograph 1942 by, and courtesy of, Joseph Glocka.)

In 1947, Joe was back at his new job doing layout and copywriting for the *Sentinel*. Joe and Mathilda were expecting their first little one, and the folks at work heard about it. One summer day, Joe came back from lunch to find his cubicle festooned with baby shower gifts—baby oil, bibs, Johnson's baby powder, a rattle, plastic diaper cover, knitted baby booties, and assorted other gifts. Joe took it all with a smile. (Photograph July 1947, courtesy of Joseph Glocka.)

# APPENDIX
## 1931 STREET NAME CHANGES

| _Old Name_ | _New Name_ |
| --- | --- |
| American Avenue | South 15 Place |
| Arizona Avenue (east part) | East Bennett Avenue |
| Arizona Avenue (west part) | East Gauer Avenue |
| Arnauld Avenue (from Canal to Blue Mnd) | North 44 Street |
| Arnauld Avenue (Canal to National) | South 44 Street |
| Auburn Lane | South 22 Place |
| Belair Place | North 28 Place |
| Beulah Avenue | South Shore Drive |
| Claremont Street | West Olive Street |
| Clinton Street | South 1 Street |
| Ealing Lane | West Congress Street |
| East Street | West Traser Street |
| East Water Street | North Water Street |
| Elizabeth Avenue | West Saveland Avenue |
| Elizabeth Avenue, East | East Saveland Avenue |
| Elliott Place | West Dewey Place |
| Garden Street | South 5 Place |
| Greenbush Street | South 4 Street |
| Grove Street | South 5 Street |
| Gruber Avenue | West Congress Street |
| Hanover Street | South 3 Street |
| Island Avenue (up to Capitol Drive) | North Palmer Street |
| Jackson Drive | West Manitoba Street |
| Lezala Place | South 21 Place |
| Luther Place | North 55 Place |
| Maurice Street | West Messmer Street |
| Midland Avenue | South 9 Place |
| Nora Place | West Melvina Street |
| North Water Street (Astor to Warren) | East Kane Place |
| Northern Place | West Hope Avenue |

| Old Name | New Name |
|---|---|
| Northway Street | West Purdue Street |
| Northwestern Avenue | East Bennett Avenue |
| Oakland Avenue | West Fairmount Avenue |
| Park Street (from Clinton to South Water Street) | East Bruce Street |
| Park Street (from Clinton Street to end) | West Bruce Street |
| Parker Avenue | South 1 Street |
| Pearl Street (Burnham to Vilter Lane) | South 21 Street |
| Pennsylvania Avenue (Delaware to Beulah) | East Bennett Avenue |
| Prospect Avenue, South | North Prospect Avenue |
| Reed Street | South 2 Street |
| Ripple Street | West Lancaster Avenue |
| Rose Hill Place | South 23 Street |
| Ruth Court | North 24 Place |
| St. Francis Avenue | West Warnimont Avenue |
| St. Francis Avenue, East | East Warnimont Avenue |
| Sercombe Road (from 35 Street to 38 Street) | West Marion Street |
| Sercombe Road (150 feet north of Hope Avenue) | North 39 Street |
| South Bay Street (Kinnickinnic to Lenox) | East Bay Street |
| South Pierce Street | West Pierce Street |
| South Water Street (Clinton to Barclay) | East Seeboth Street |
| South Water Street (Clinton to Reed) | West Seeboth Street |
| Stange Avenue | West Stark Street |
| Sylvester Place | South 10 Place |
| Townsend Court | West Townsend Street |
| Valley Road | South 2 Street |
| West Street | South Greeley Street |
| West Water Street | North Plankinton Avenue |

| Old Name | New Name |
|---|---|
| 1 Avenue (Canal to Fowler) | North 6 Street |
| 1 Avenue (Canal to end) | South 6 Street |
| 2 Avenue | South 7 Street |
| 3 Avenue | South 8 Street |
| 4 Avenue | South 9 Street |
| 5 Avenue | South 10 Street |
| 6 Avenue | South 11 Street |
| 7 Avenue | South 12 Street |
| 8 Avenue | South 13 Street |
| 9 Avenue | South 14 Street |
| 10 Avenue | South 15 Street |
| 11 Avenue | South 16 Street |
| 12 Avenue | South 17 Street |
| 13 Avenue | South 18 Street |
| 14 Avenue | South 19 Street |
| 15 Avenue | South 20 Street |
| 16 Avenue | South 21 Street |
| 17 Avenue | South 22 Street |
| 18 Avenue | South 23 Street |
| 19 Avenue | South 24 Street |

| Old Name | New Name |
|---|---|
| West 19 Street | North 19 Place |
| 20 Avenue | South 25 Street |
| 21 Avenue | South 26 Street |
| 22 Avenue | South 27 Street. |
| 23 Avenue | South 28 Street |
| 24 Avenue | South 29 Street |
| West 24 Street | North 24 Place |
| 25 Avenue | South 30 Street |
| 26 Avenue | South 31 Street |
| 27 Avenue | South 32 Street |
| 28 Avenue | South 33 Street |
| 29 Avenue | South 34 Street |
| 30 Avenue | South 35 Street |
| 31 Avenue | South 36 Street |
| 32 Avenue | South 37 Street |
| 33 Avenue | South 38 Street |
| 34 Avenue | South 39 Street |
| 35 Avenue | South 40 Street |
| 36 Avenue | South 41 Street |
| West 36 Avenue | South 42 Street |
| 37 Avenue | South 43 Street |
| West 37 Street  (Juneau to Vliet) | North 37 Street |
| West 37 Street (Park Hill to Wisconsin) | North 38 Street |
| 38 Avenue | South 44 Street |
| 39 Avenue | South 45 Street |
| West 39 Avenue | South 46 Street |
| 40 Avenue | South 47 Street |
| 41 Avenue | South 48 Street |
| 42 Avenue | South 49 Street |
| West 47 Street | North 48 Street |
| 50 Street (State to Juneau) | North 50 Place |
| West 50 Street | North 50 Place |
| 64 Street (Center to Lisbon) | North Carlton Place |

# INDEX